Naked New York

Naked New York

Greg Friedler

W.W. Norton & Company
New York ⌒ London

Copyright © 1997 by Greg Friedler

The text and display type of this book are composed in Electra
Manufacturing by Arnoldo Mondadori Editore, Verona, Italy
Book design by Calvin Chu
Cover Illustration: Greg Friedler

Library of Congress Cataloging-in-Publication Data

Friedler, Greg.
Naked New York / Greg Friedler.
 p. cm.
ISBN 0-393-04109-3. — **ISBN 0-393-31646-7** (pbk.)
1. Photography of the nude.
2. Photography, Artistic.
3. Photography—New York (State) I. Title.
TR674.F68 1997
779'.21—dc21 96-39282
 CIP

W. W. Norton & Company, Inc., 500 Fifth Avenue, New York, N.Y. 10110
 http://www.wwnorton.com

W. W. Norton & Company Ltd., 10 Coptic Street, London WCIA 1PU

2 3 4 5 6 7 8 9 0

Naked New York is the manifestation of my desire to document the various types of people who exist within humanity, a desire driven by my intense curiosity. I am interested in what people do and how they live. I'm interested in their existence.

As I pass people on the street, certain questions run through my mind. Who are they? What kind of upbringing did they have? What are their aspirations in life? What do they do for a living? What is their sexual orientation? What issues are important to them?

For this project, I wanted to photograph "naked" people rather than "nude" figures. As I see it, photographing some-one naked is about trying to get at some kind of truth, where-as photographing someone nude is linked more to sexual gratification, eroticism, or our conventions of beauty. In a photograph, a naked person stands for and represents him or herself, whereas a nude wears the invisible outfit of an ideal or an object of desire, which prevents us from coming in contact with the real person. My concern is not to represent the way people want to look, but to record the way they do look.

I photographed each person clothed and naked in order to show the two sides of the same person, the public as well as the private. The clothed version, as they are seen everyday in society, is only part of the truth. It is almost as if we were blind. The blind can only achieve one sense of a person through their hearing, just as we, the sighted, only have one sense of a clothed individual.

Clothes are voluntary and alter our appearance accord-ing to how we would like to look, or how we feel we should look. Nakedness, on the other hand, reveals people the way

they are. Nakedness is a great equalizer. We can focus on a naked person and not on the expectations—both ours and theirs—that clothing produces about their occupation or their place in society.

I am often asked why people participated in this project. This is a valid question in a project where the participants show up with the knowledge that they are going to take off their clothes and be photographed by a complete stranger without receiving any monetary compensation. I believe they participate for a number of different reasons. I think that a lot people in New York (and elsewhere) are starving for attention. The people in this project enjoy the fact that they have my full attention and that I am attempting to connect with them on some level. For some, I become a temporary friend or confidant. Perhaps people take part because they receive some kind of gratification from it, sexual or otherwise, or because they are exhibitionists at heart. And I think some participate because they enjoy art, or they want to do something spontaneous and different from their regular routine. Others participate because they want to have a record that they existed in a certain place and time.

My most memorable sitting occurred on the second to last day of shooting. I opened the curtain to find a gray-haired man holding a cane. When I noticed that he had uncontrollable tics, I knew that this was the man with Parkinson's disease I had spoken with on the phone. I was reminded of Muhammad Ali, who received the torch just nights before at the 1996 Olympic Games in Atlanta. It was one of the most touching and historic moments of my life, seeing the great Ali, who also suffers from Parkinson's, as he struggled to light the Olympic Flame.

The shoot with this man went the same as the others, yet afterward I took more time to speak with him. He told me that he was a grandfather of three, that he used to work at a major hotel doing room service, and that on August 14, 1996, he was going into the hospital for controversial brain surgery to try and alleviate some of his symptoms. He told me that a gambling habit cost him his life savings, his wife

of 25 years, and made him homeless. Despite it all, the man had an incredible zest for life. He said, "I really enjoy life and life, you know, is all in your mind."

As he exited down the hall, I realized that I had met an everyday Muhammad Ali. I will never forget this extraordinary man or his uplifting spirit.

Update: I spoke with him in September and he was happy because his surgery was a major success and he feels great.

I would like to thank everyone who participated in the project, Cesar Galindo for his friendship and for allowing me to use his loft, and Jordan Schaps for all of his help and guidance. But above all, I owe an enormous debt of gratitude to my wonderful parents for their unwavering love and support. Thanks Mom and Dad—this book is dedicated to you!

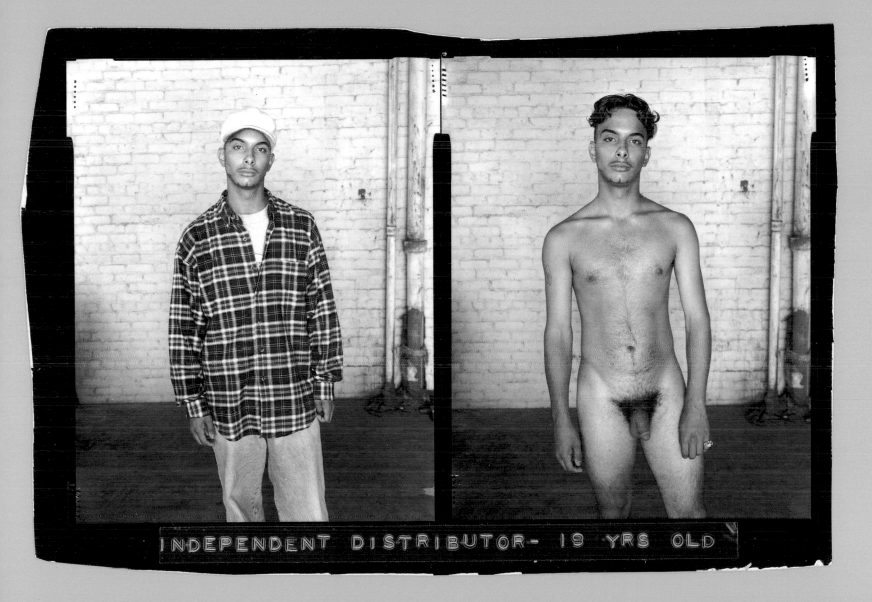

INDEPENDENT DISTRIBUTOR— 19 YRS OLD

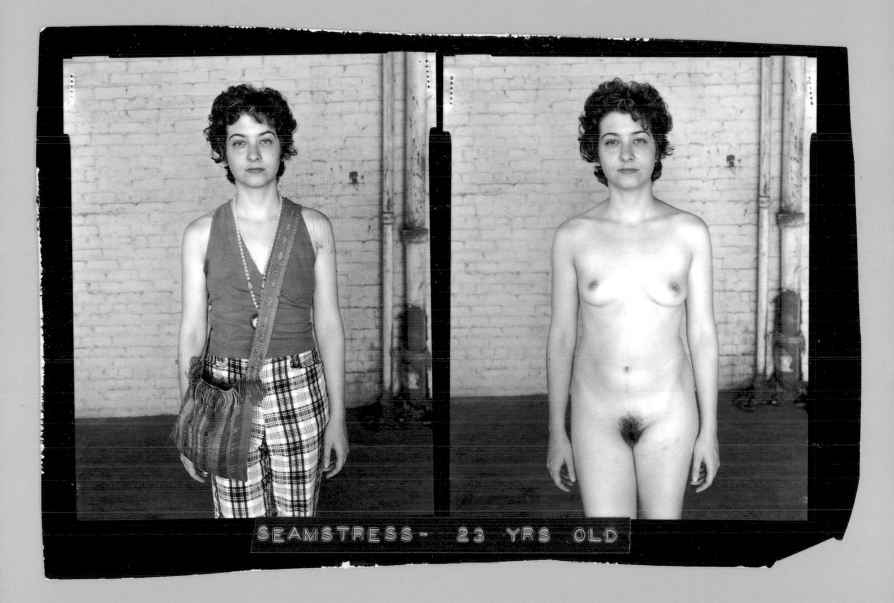

SEAMSTRESS - 23 YRS OLD

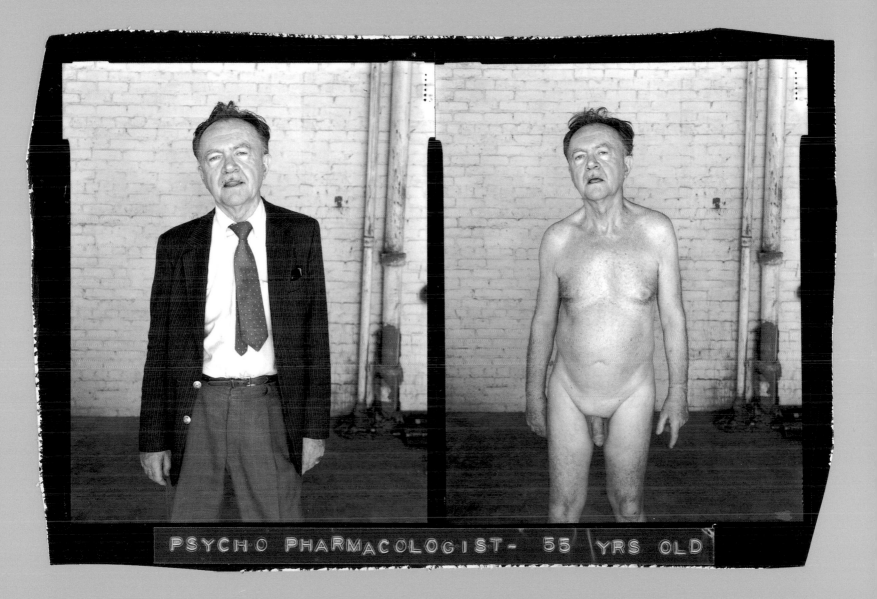

PSYCHO PHARMACOLOGIST- 55 YRS OLD

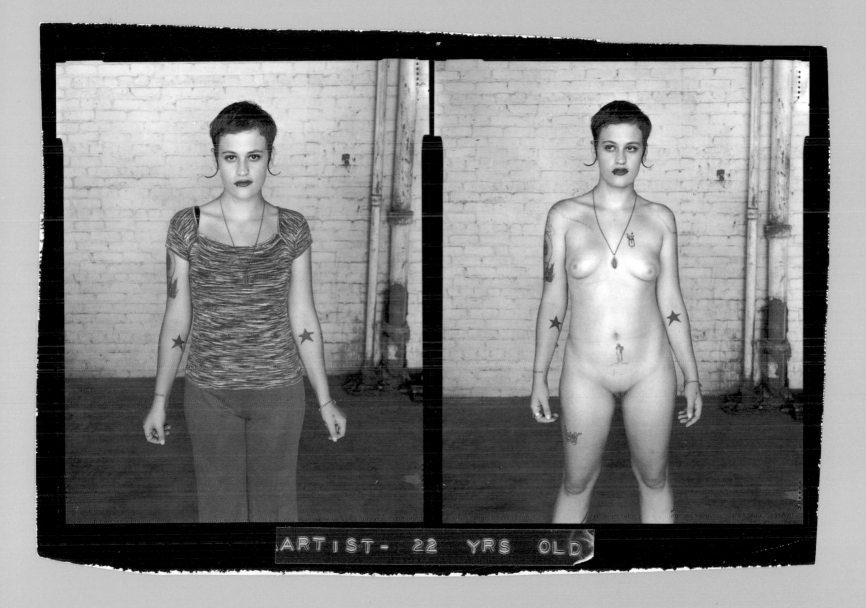

ARTIST - 22 YRS OLD

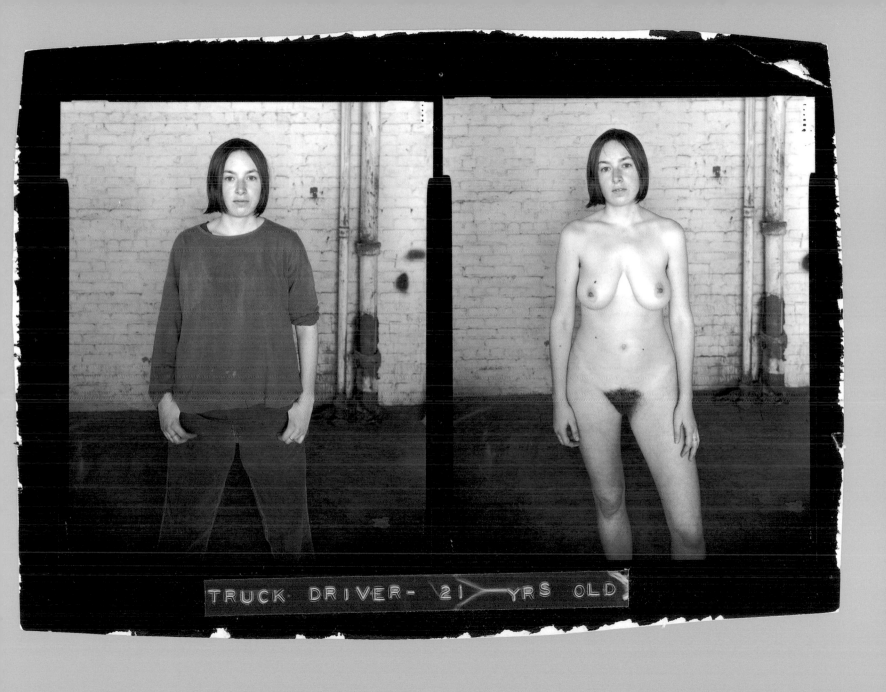

TRUCK DRIVER - 21 YRS OLD

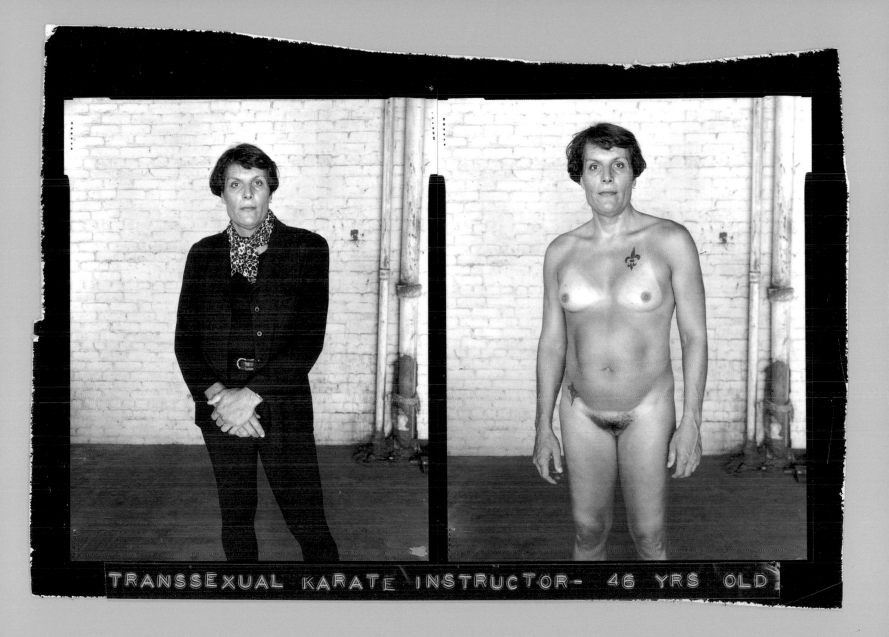

TRANSSEXUAL KARATE INSTRUCTOR— 46 YRS OLD

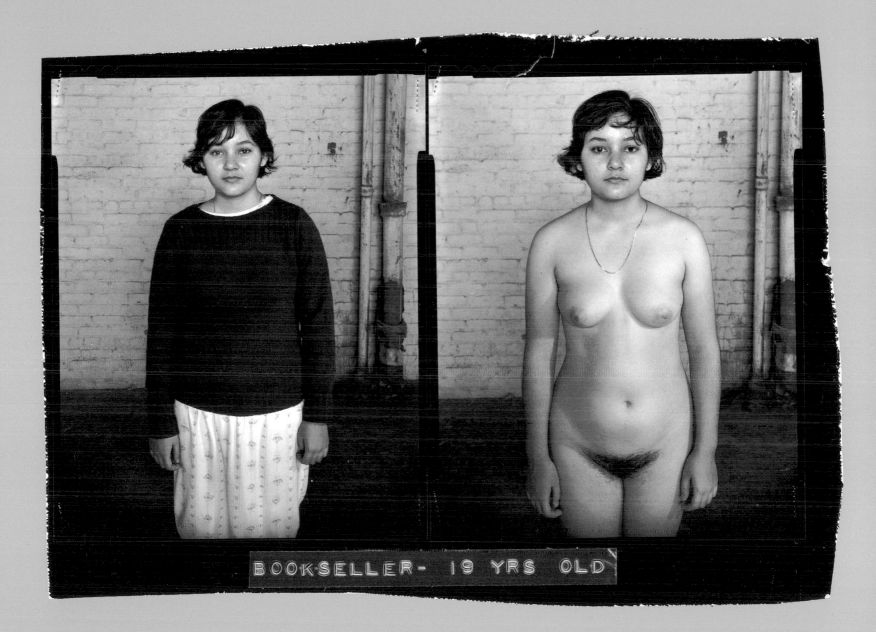

BOOKSELLER- 19 YRS OLD

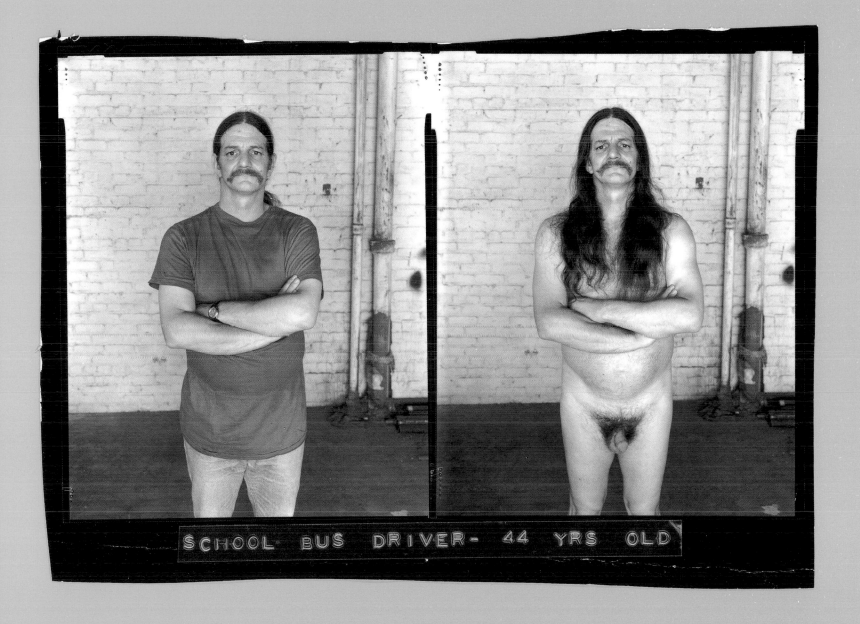

SCHOOL BUS DRIVER- 44 YRS OLD

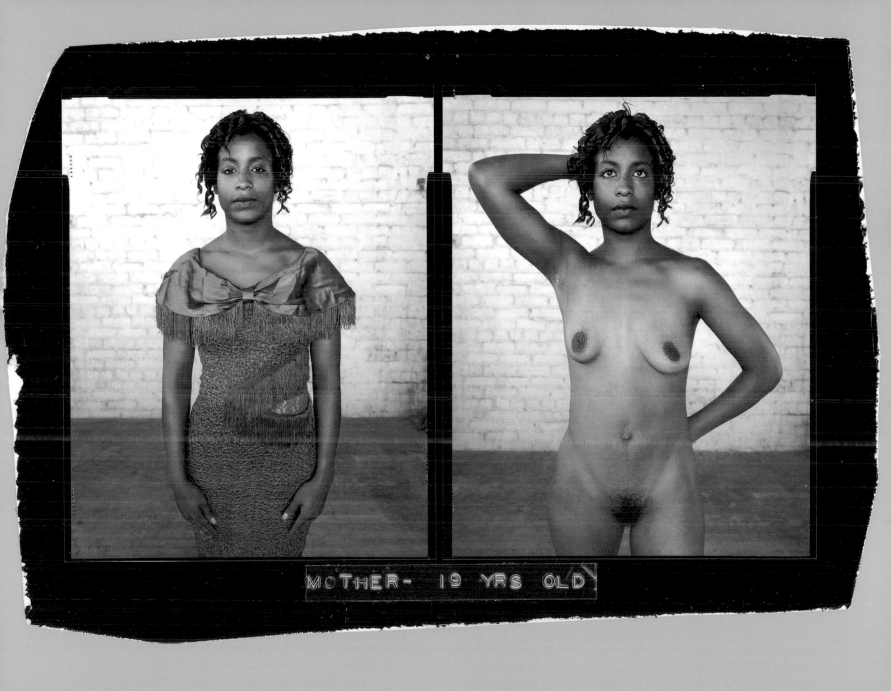

MOTHER- 19 YRS OLD

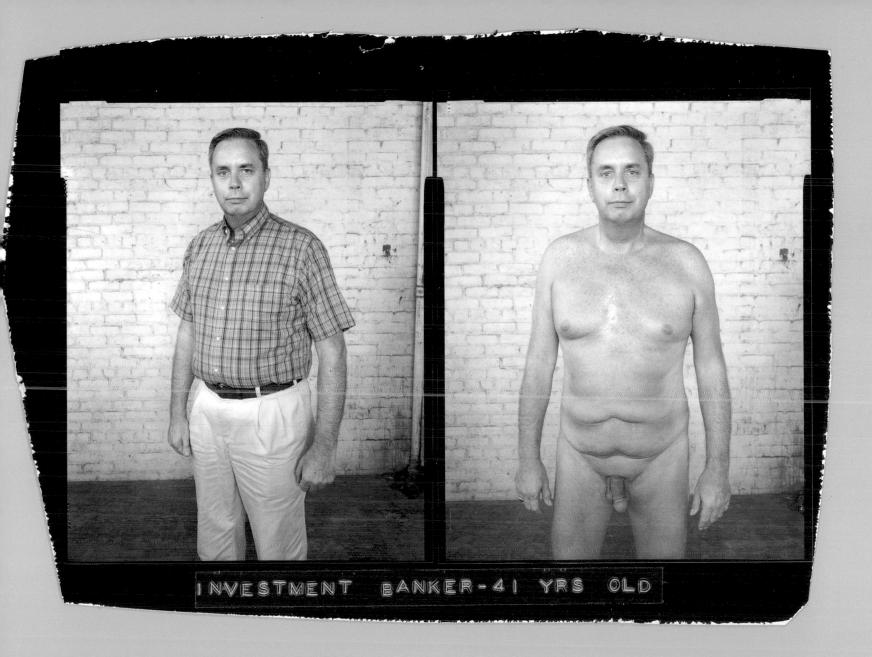

INVESTMENT BANKER-41 YRS OLD

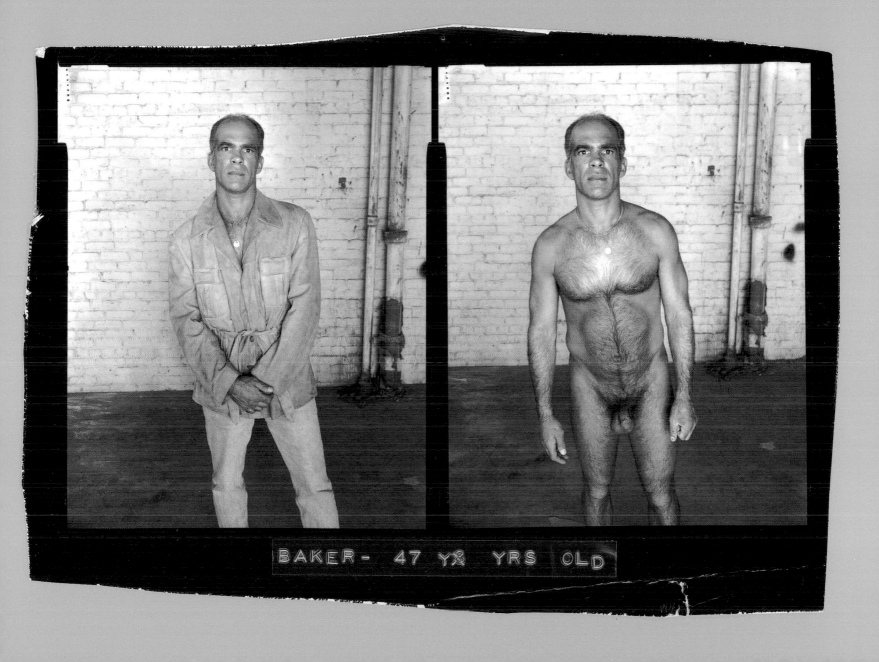

BAKER - 47 YS YRS OLD

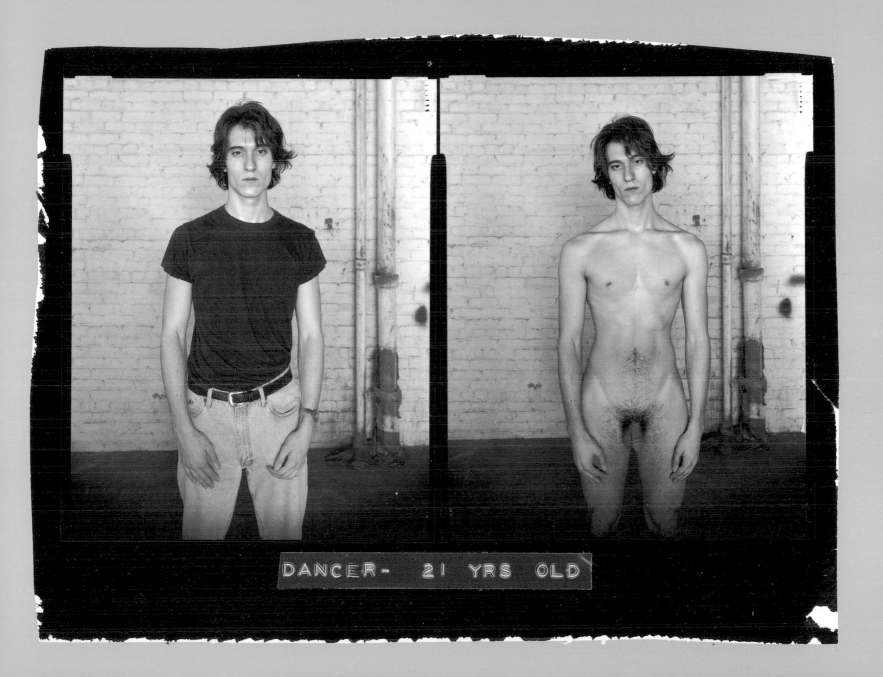

DANCER- 21 YRS OLD

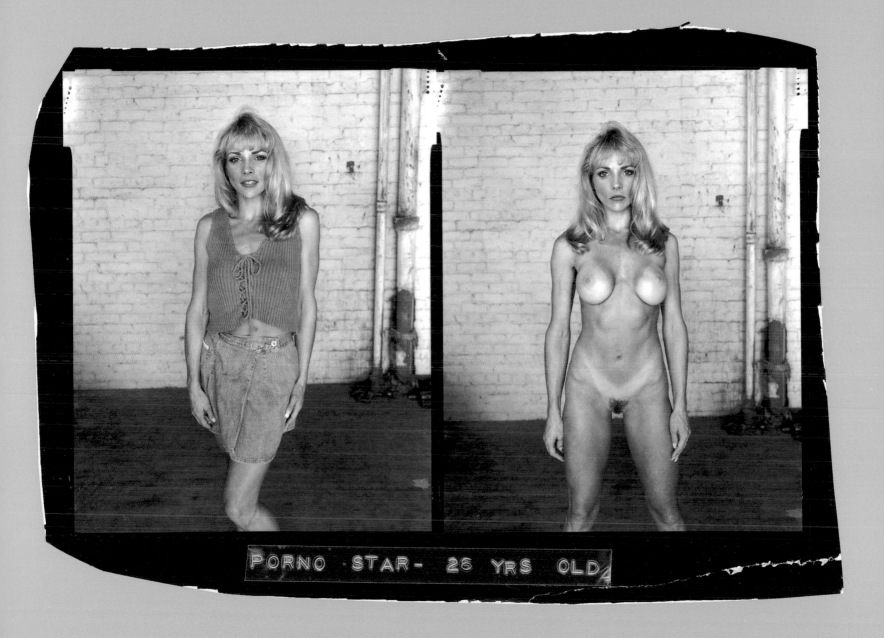

PORNO STAR- 26 YRS OLD

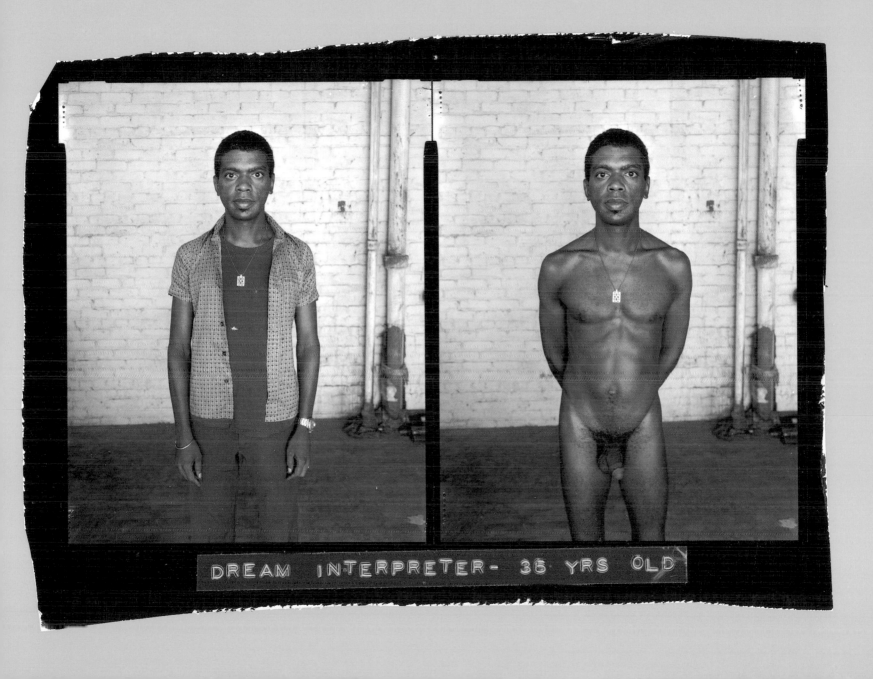

DREAM INTERPRETER- 35 YRS OLD

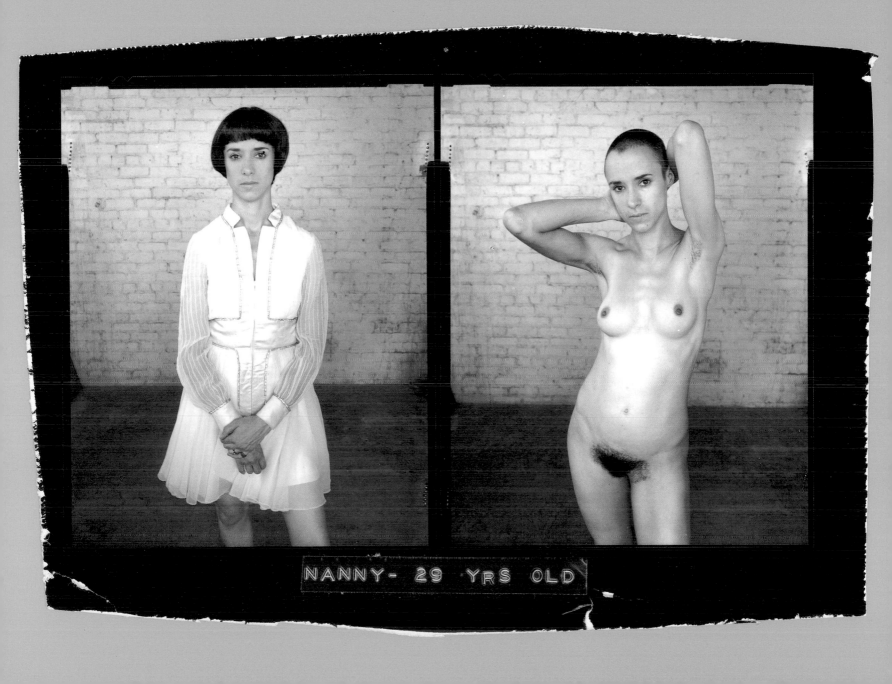

NANNY- 29 YRS OLD

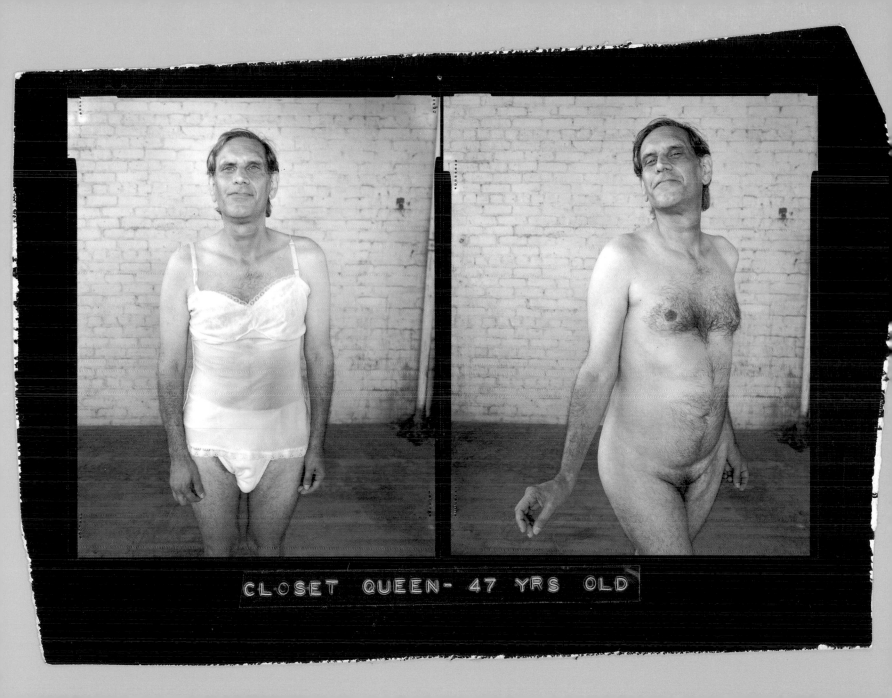

CLOSET QUEEN- 47 YRS OLD

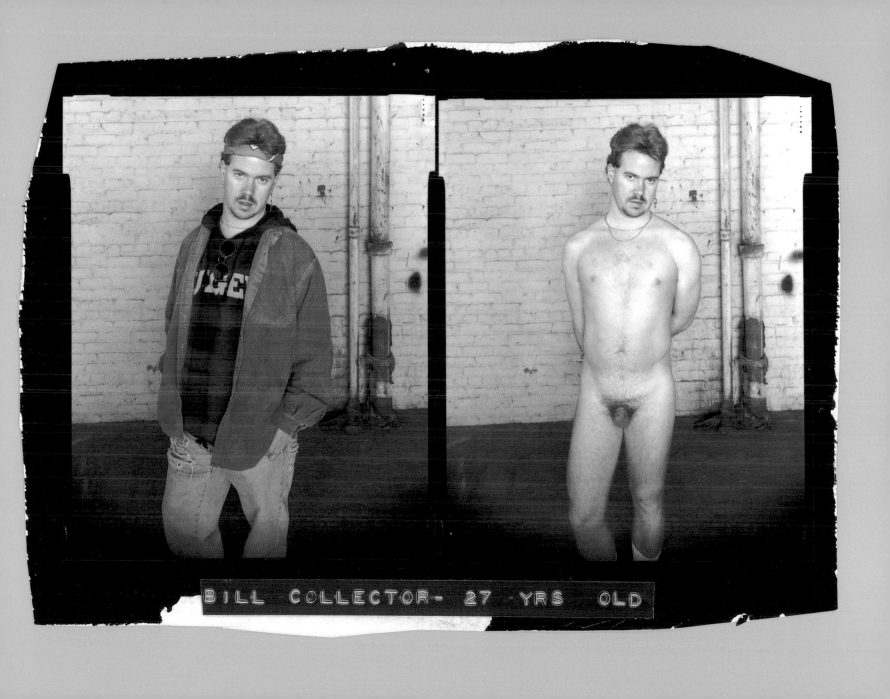

BILL COLLECTOR- 27 YRS OLD

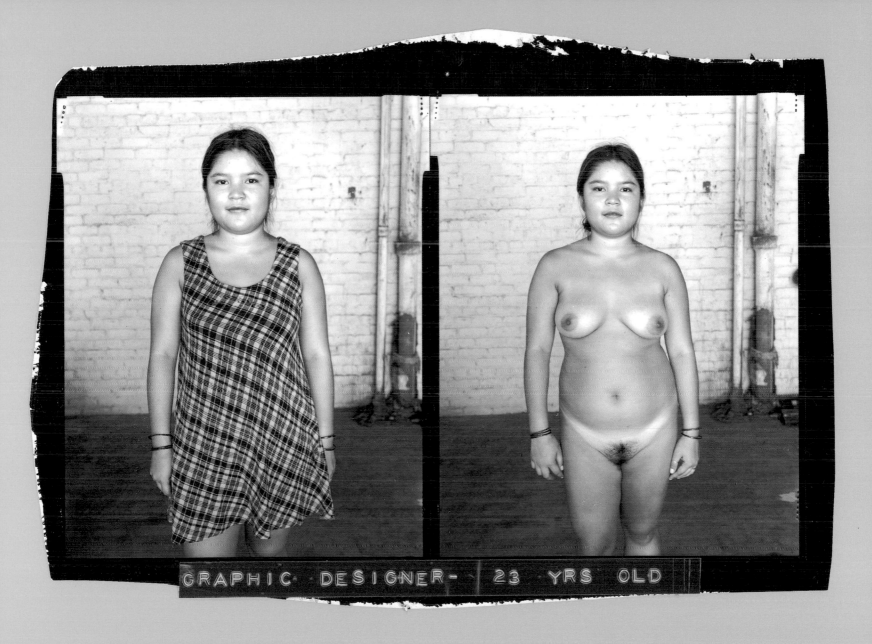

GRAPHIC · DESIGNER— 23 YRS OLD

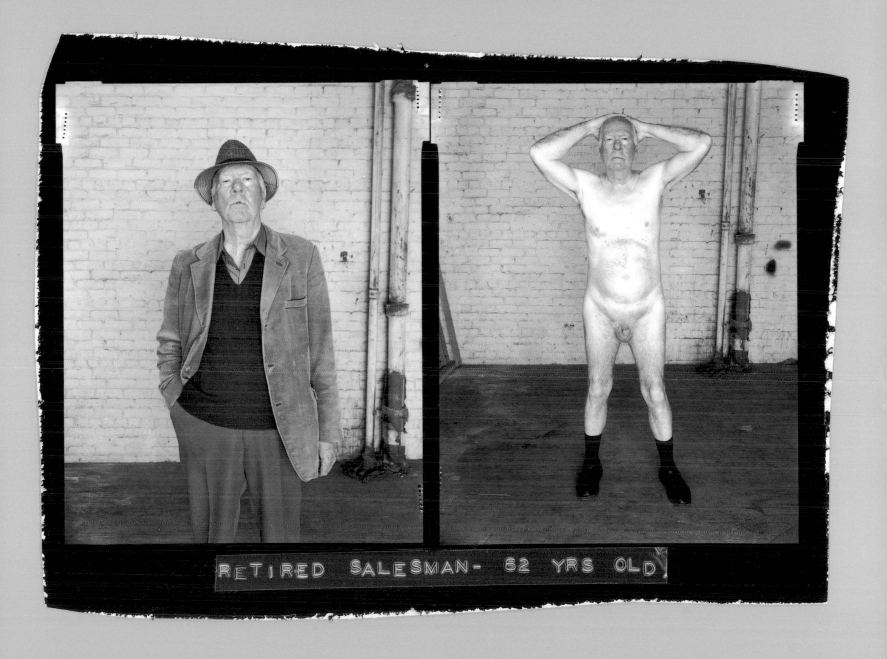

RETIRED SALESMAN- 62 YRS OLD

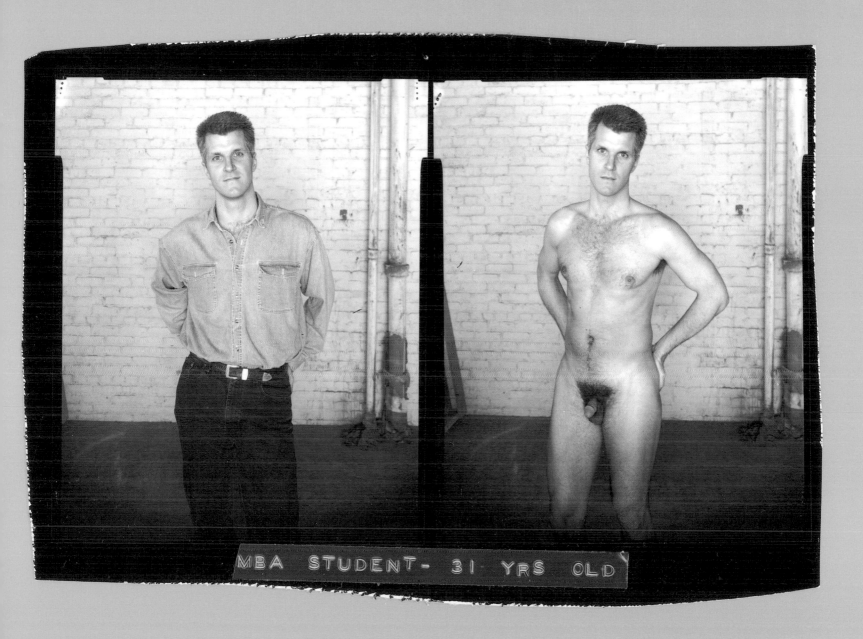

MBA STUDENT- 31 YRS OLD

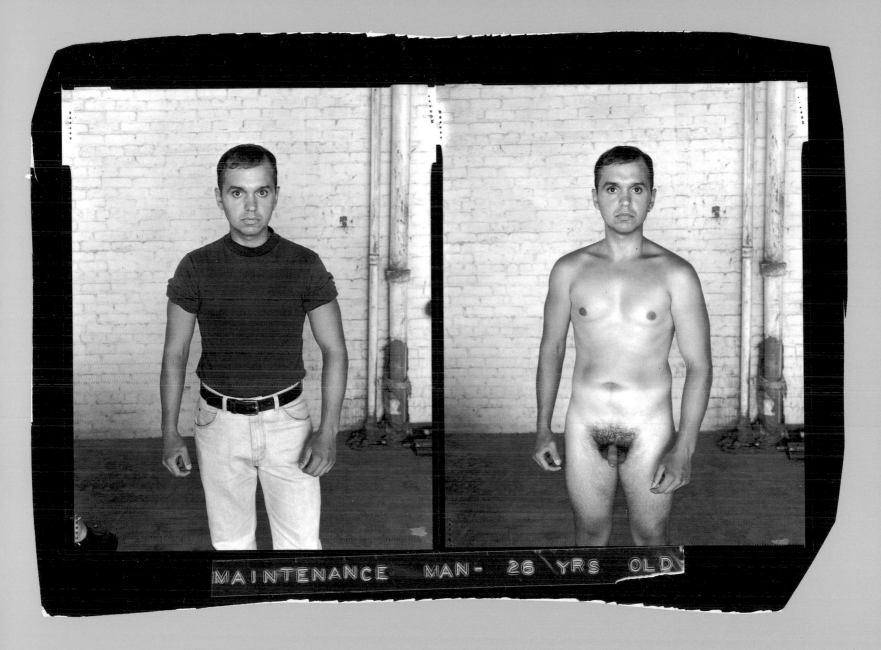

MAINTENANCE MAN - 26 YRS OLD

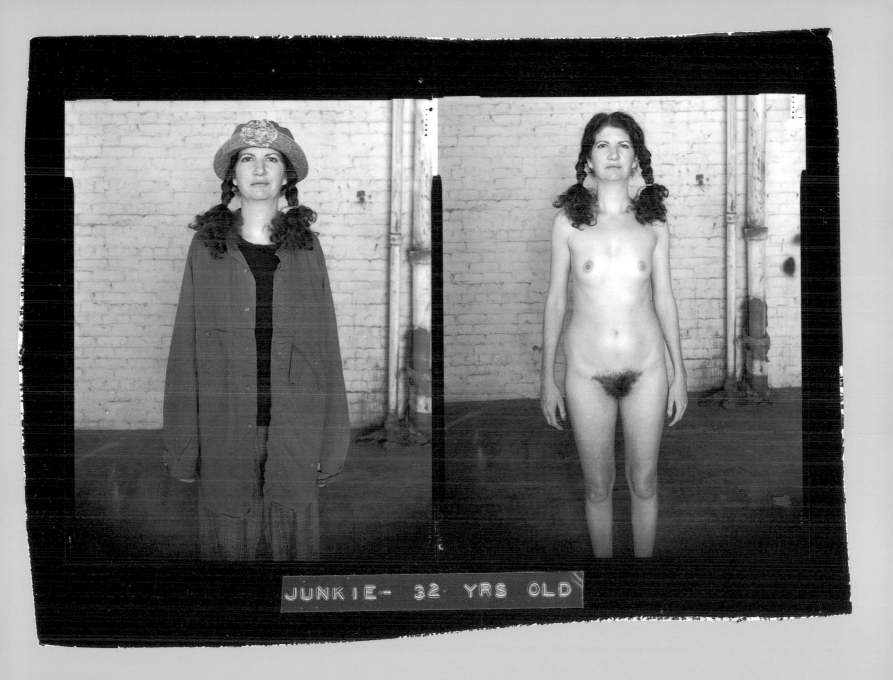

JUNKIE- 32 YRS OLD

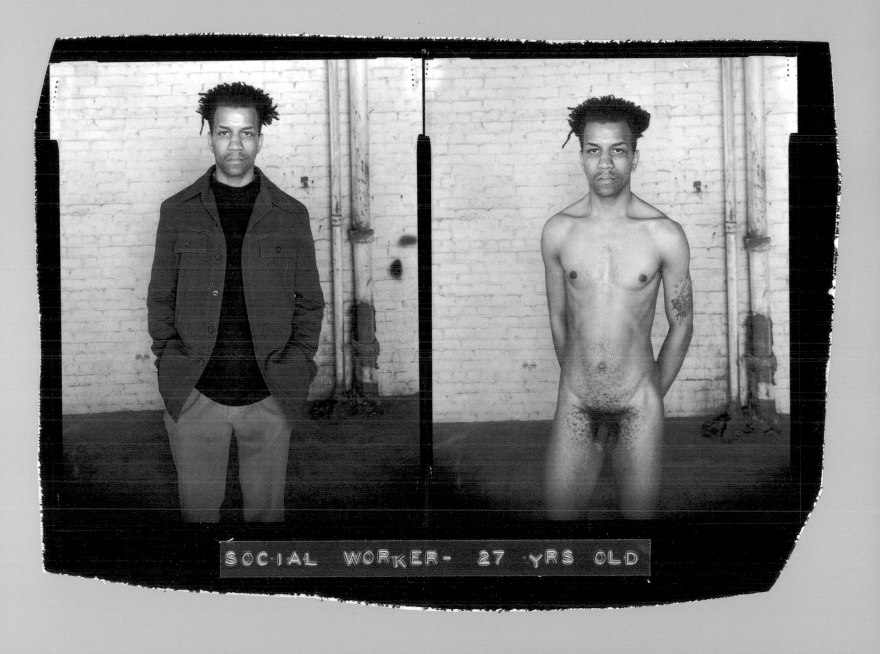

SOCIAL WORKER- 27 YRS OLD

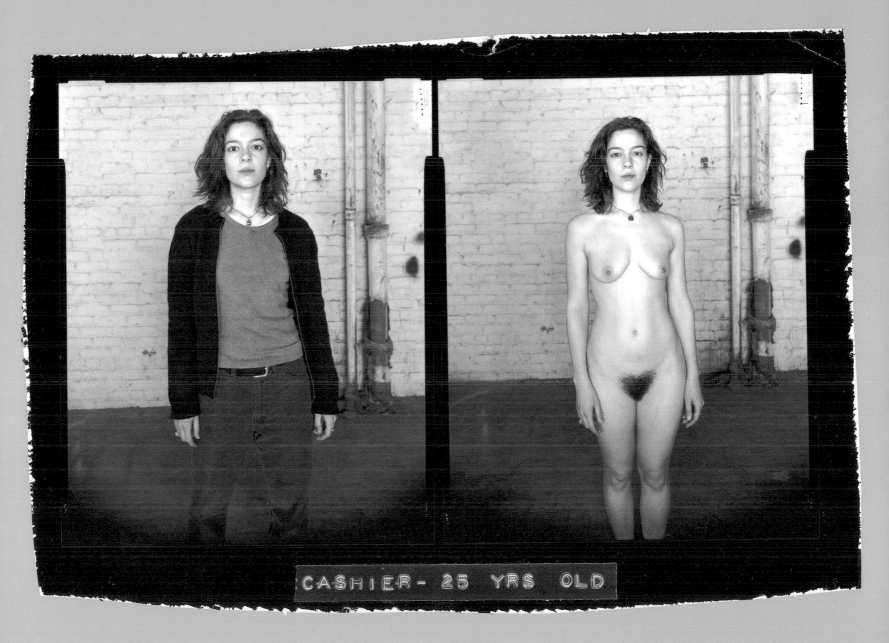

CASHIER- 25 YRS OLD

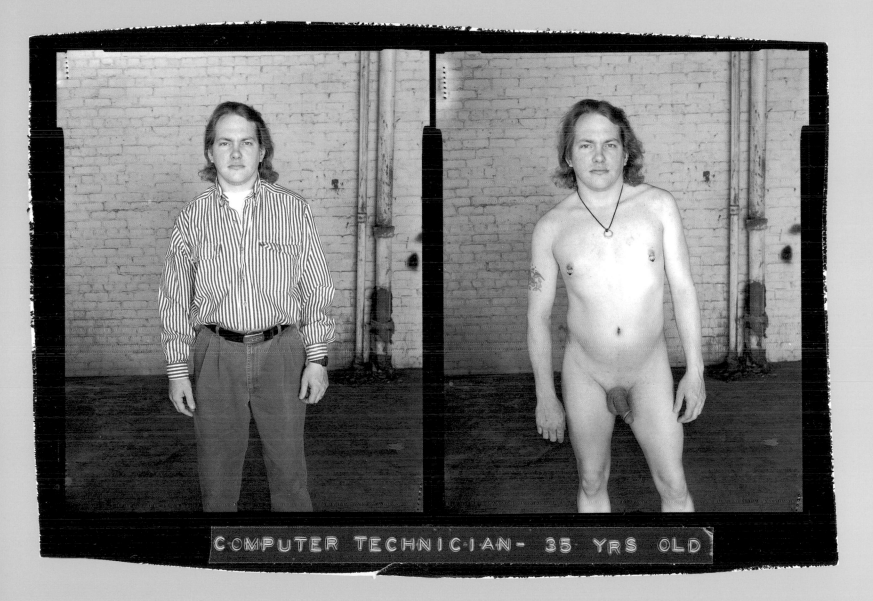

COMPUTER TECHNICIAN- 35 YRS OLD

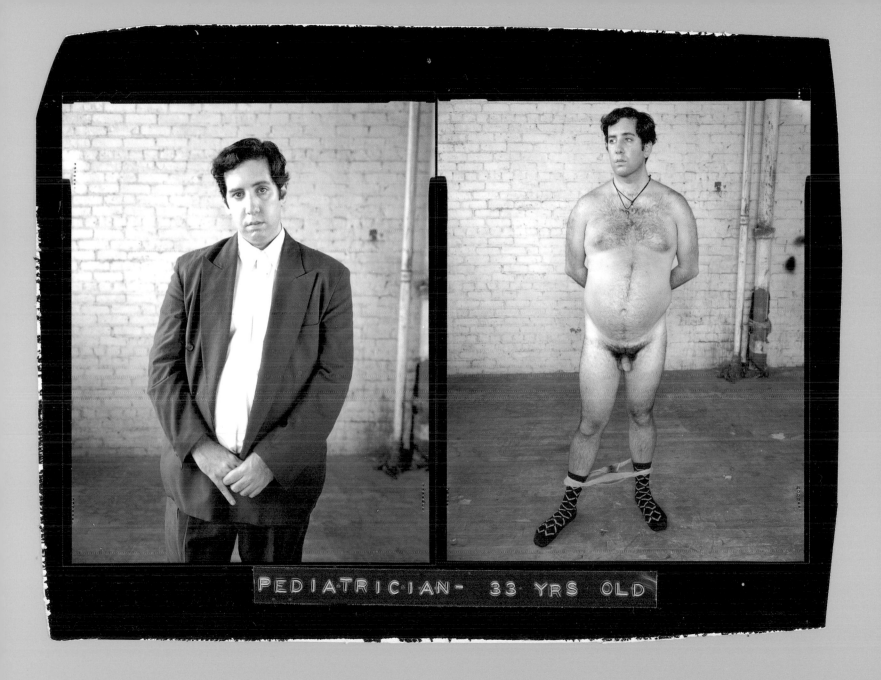

PEDIATRICIAN - 33 YRS OLD

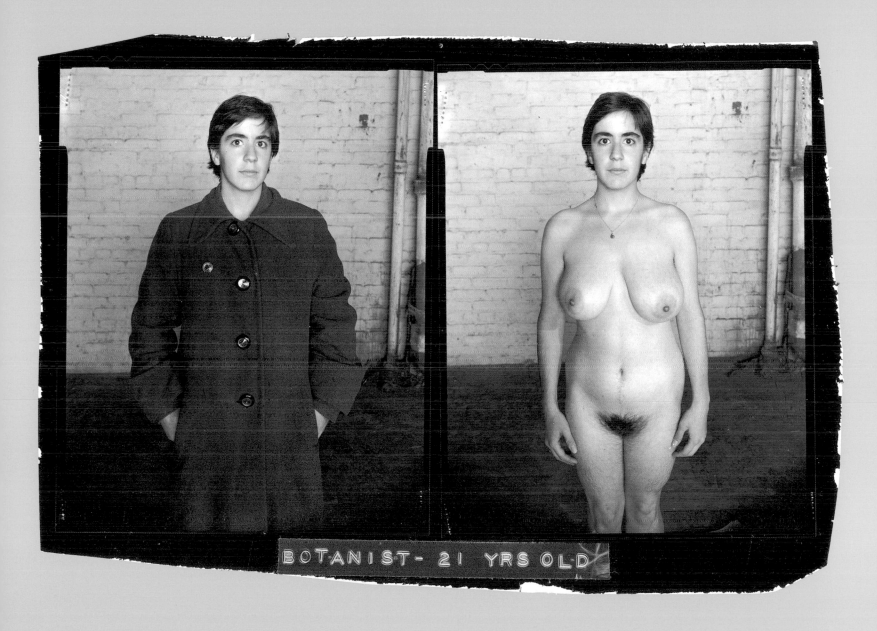

BOTANIST - 21 YRS OLD

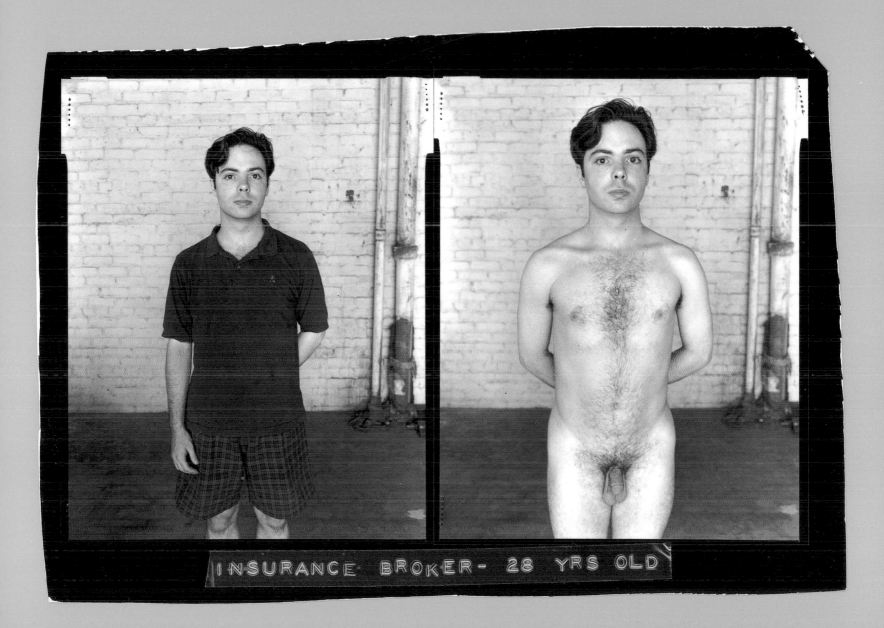

INSURANCE BROKER- 28 YRS OLD

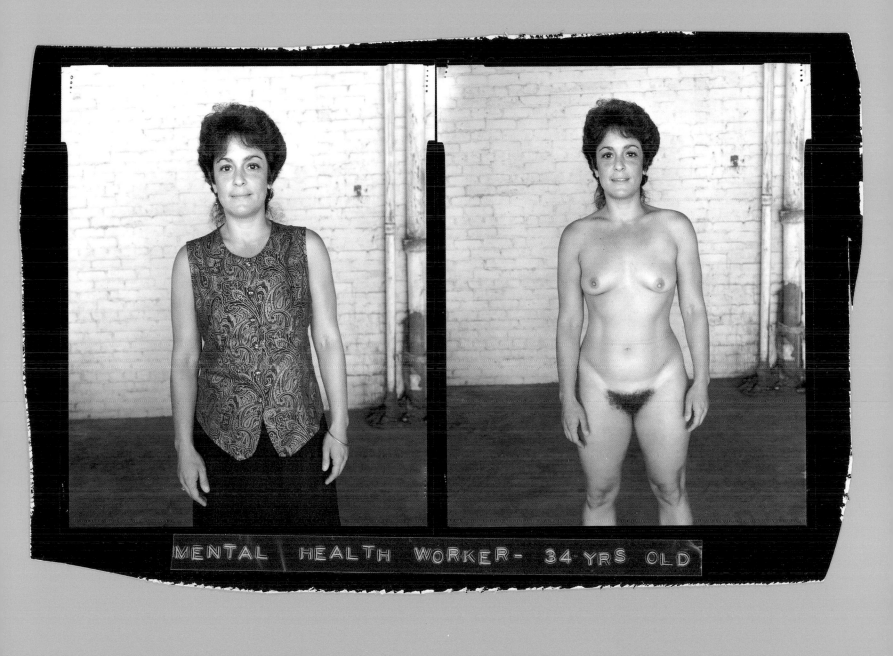

MENTAL HEALTH WORKER - 34 YRS OLD

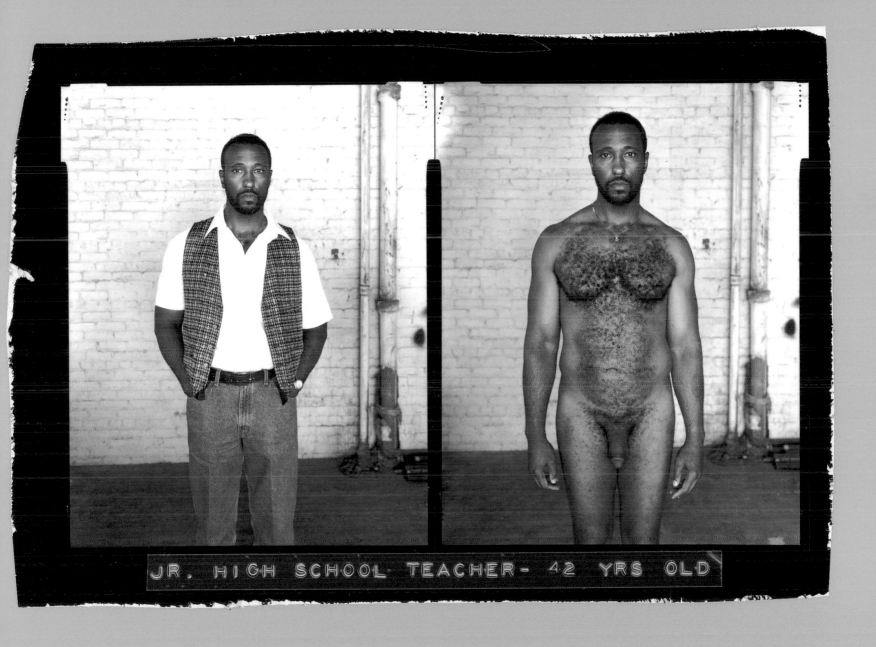

JR. HIGH SCHOOL TEACHER- 42 YRS OLD

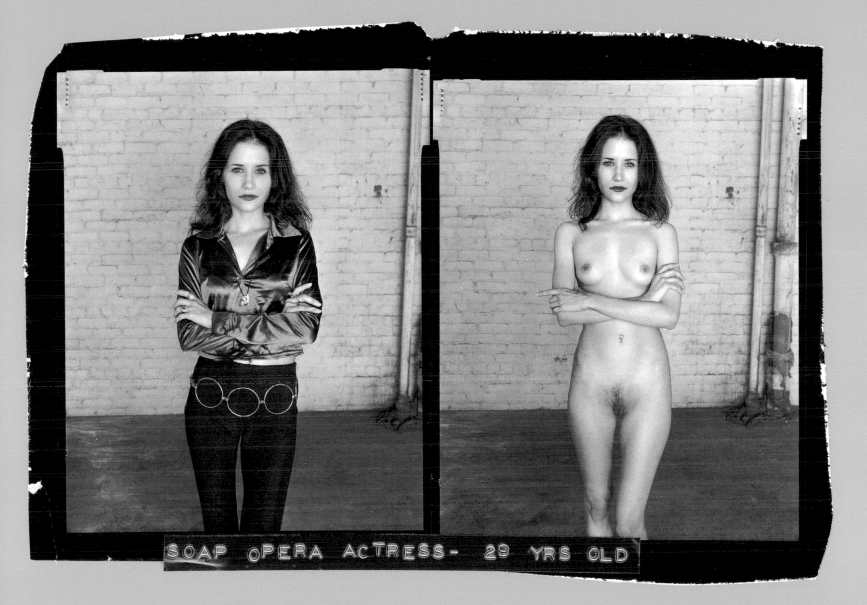

SOAP OPERA ACTRESS- 29 YRS OLD

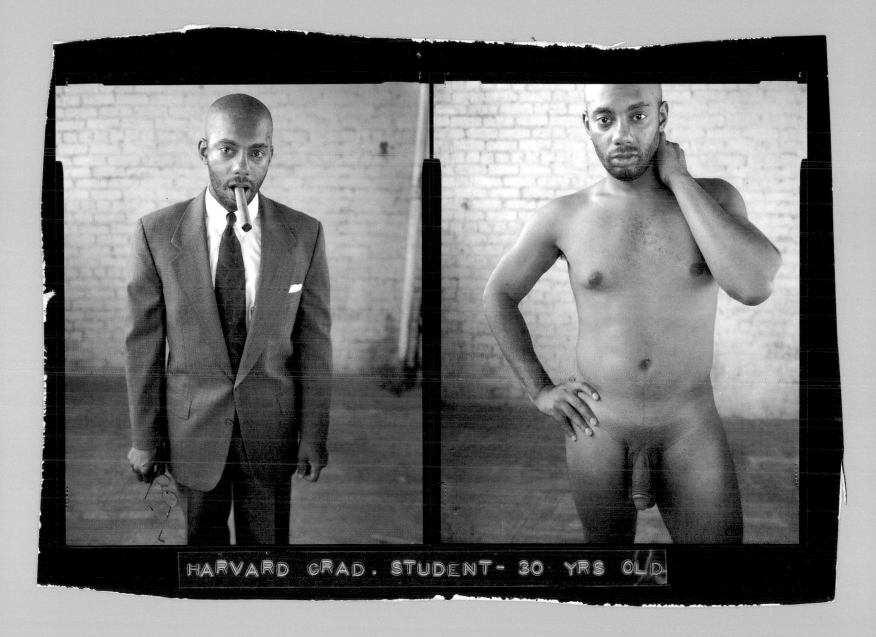

HARVARD GRAD. STUDENT - 30 YRS OLD

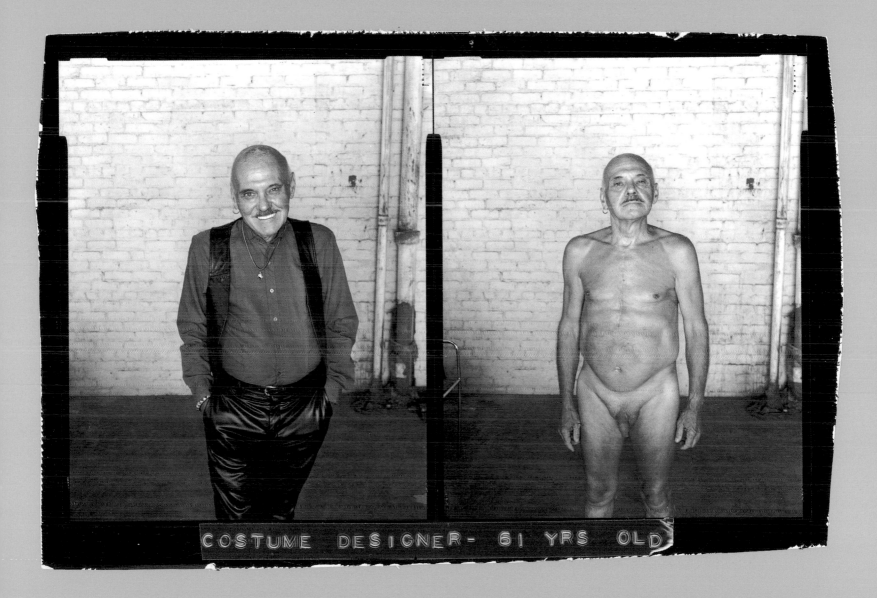

COSTUME DESIGNER - 61 YRS OLD

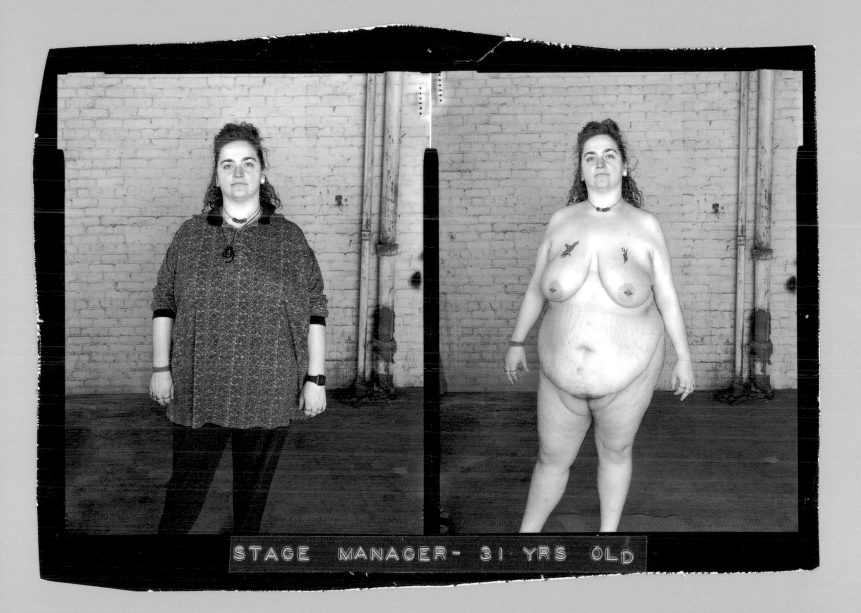

STAGE MANAGER- 31 YRS OLD

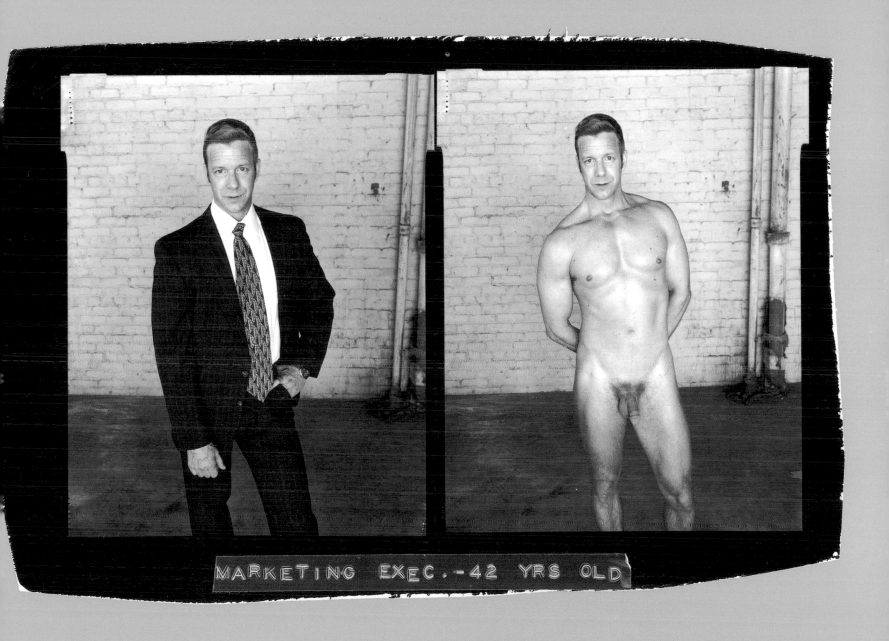

MARKETING EXEC.-42 YRS OLD

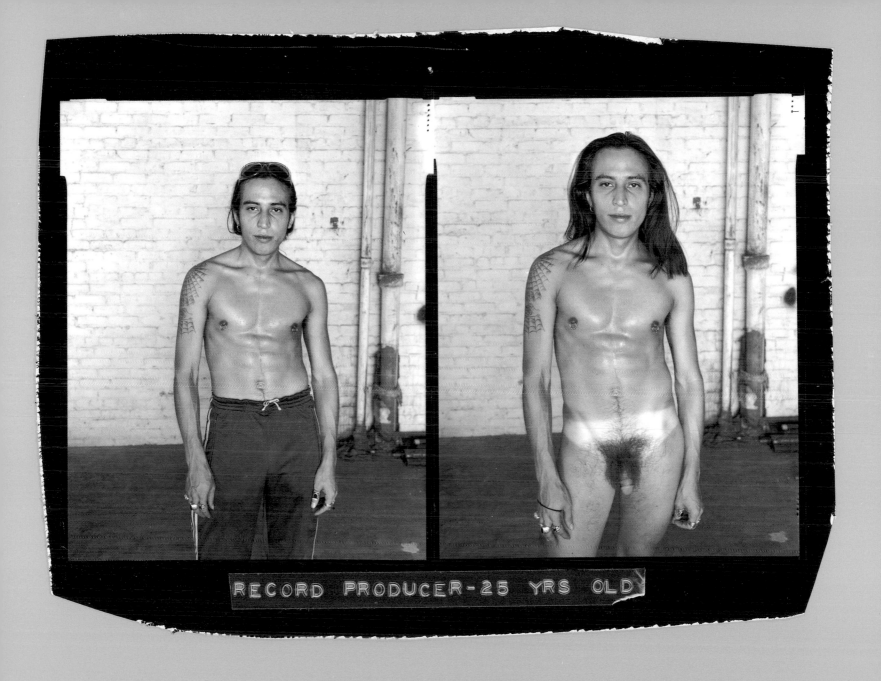

RECORD PRODUCER- 25 YRS OLD

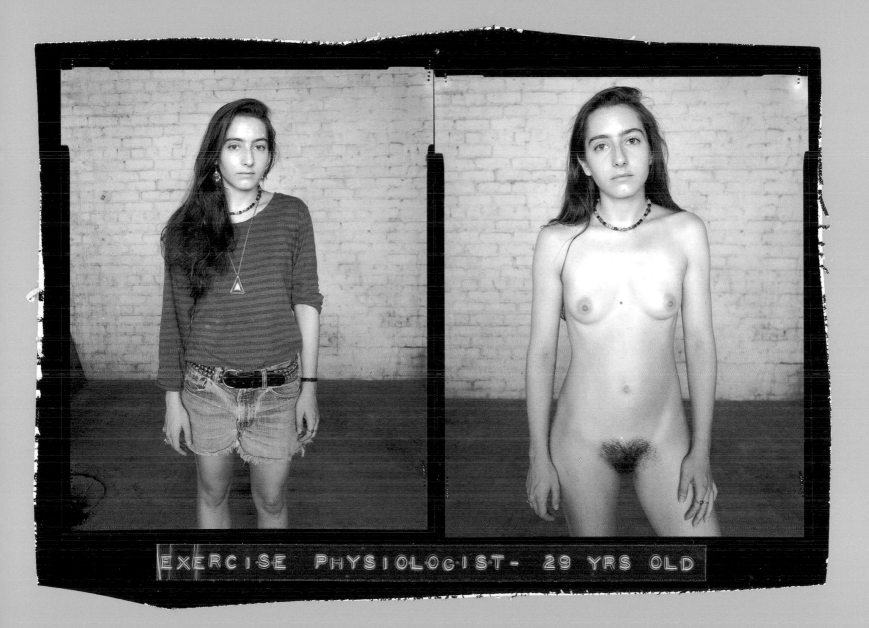

EXERCISE PHYSIOLOGIST- 29 YRS OLD

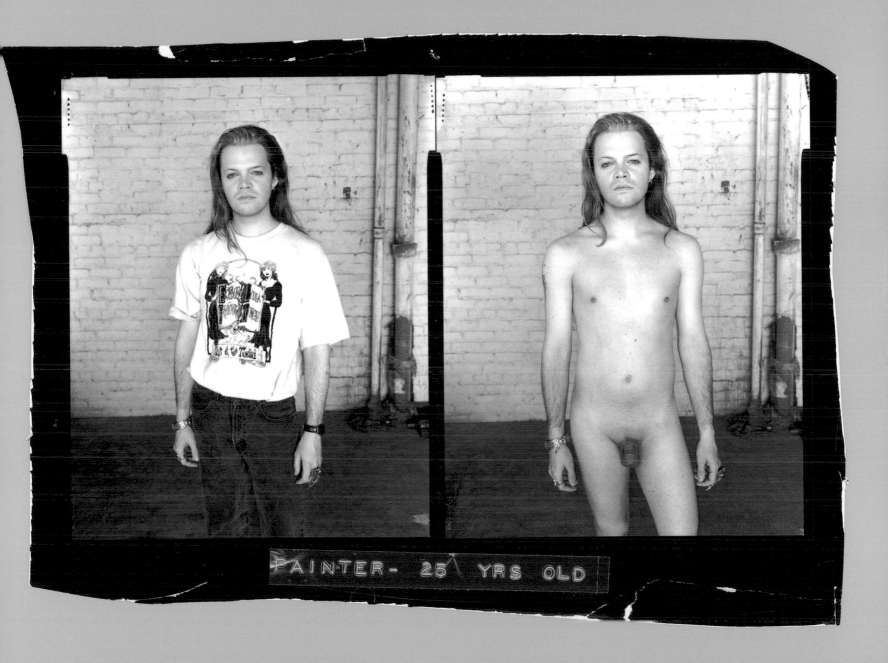

PAINTER - 25 YRS OLD

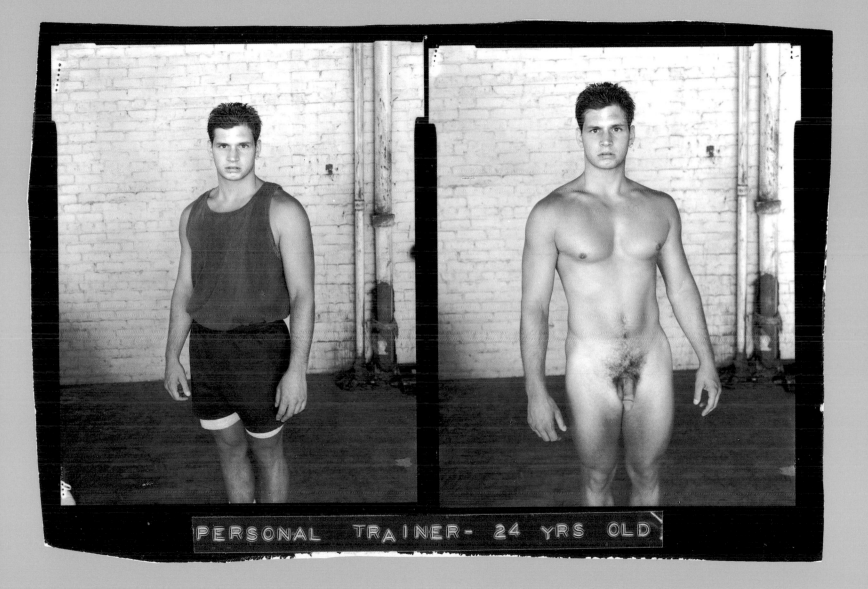

PERSONAL TRAINER- 24 YRS OLD

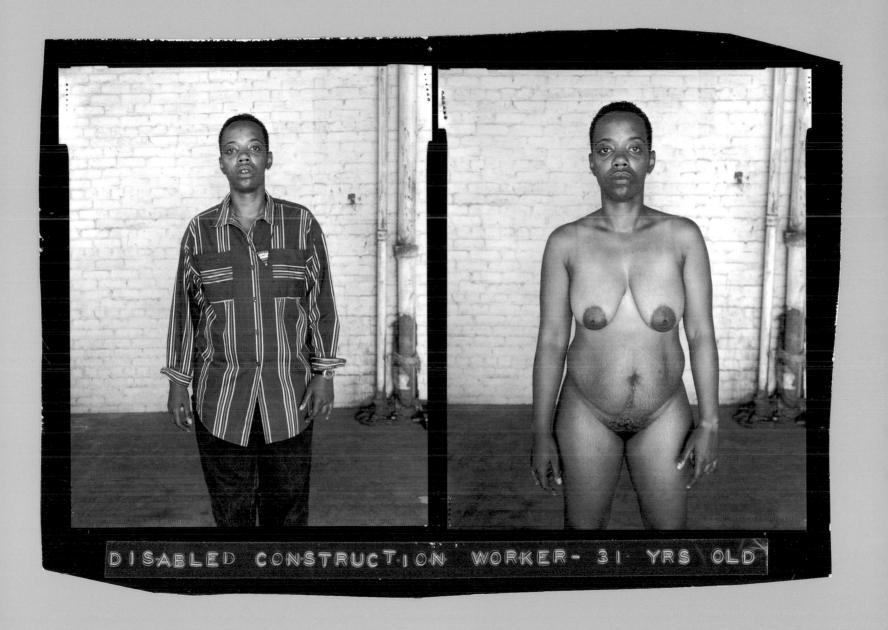

DISABLED CONSTRUCTION WORKER- 31 YRS OLD

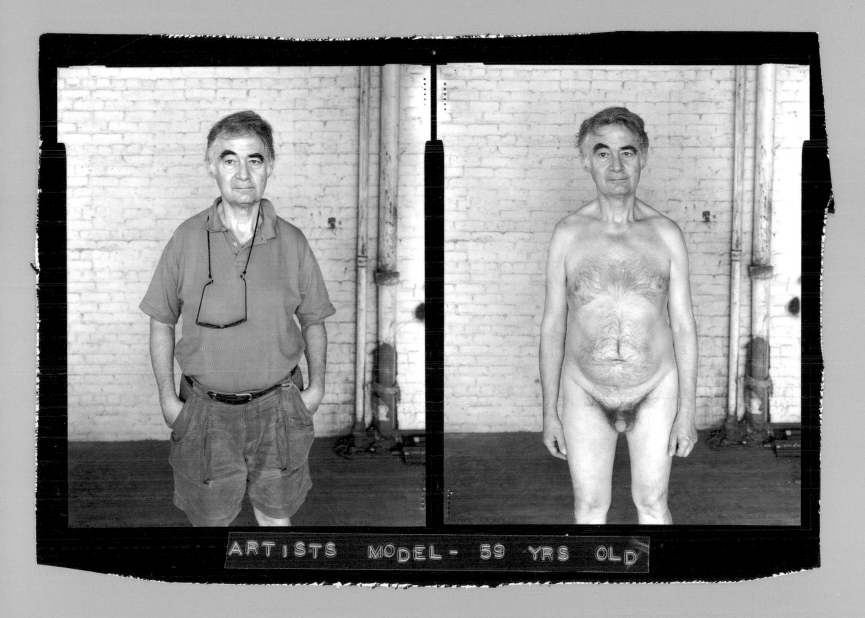

ARTISTS MODEL - 59 YRS OLD

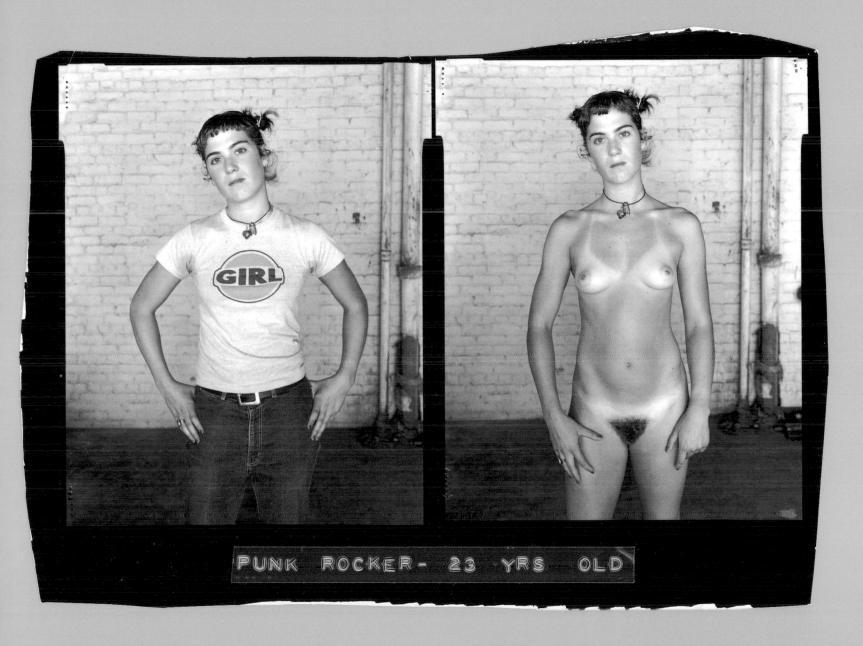

PUNK ROCKER - 23 YRS OLD

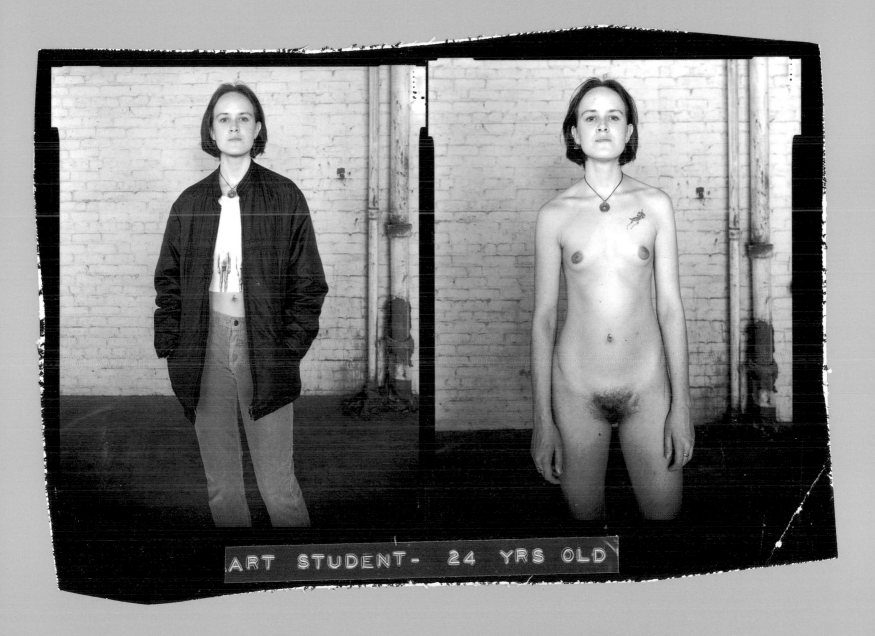

ART STUDENT - 24 YRS OLD

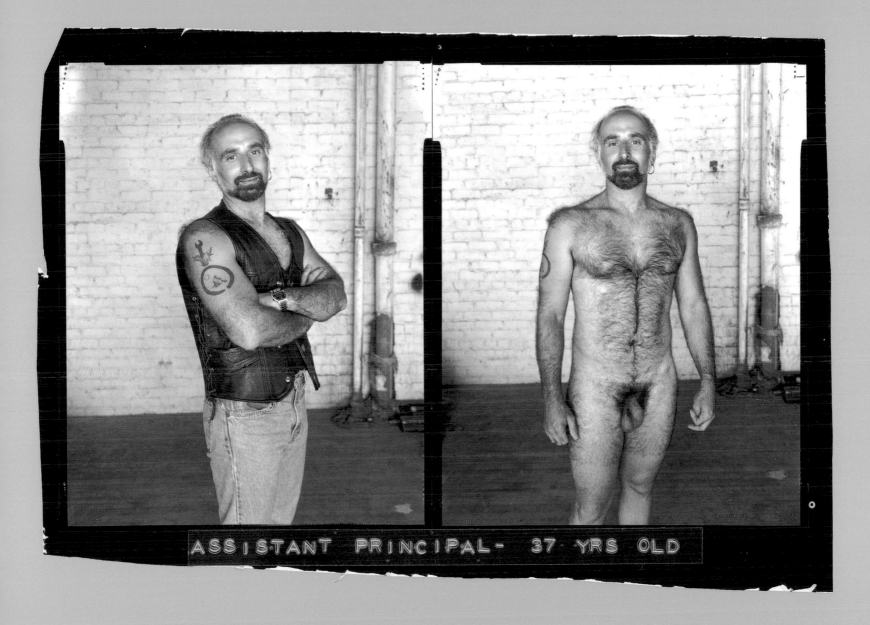

ASSISTANT PRINCIPAL- 37 YRS OLD

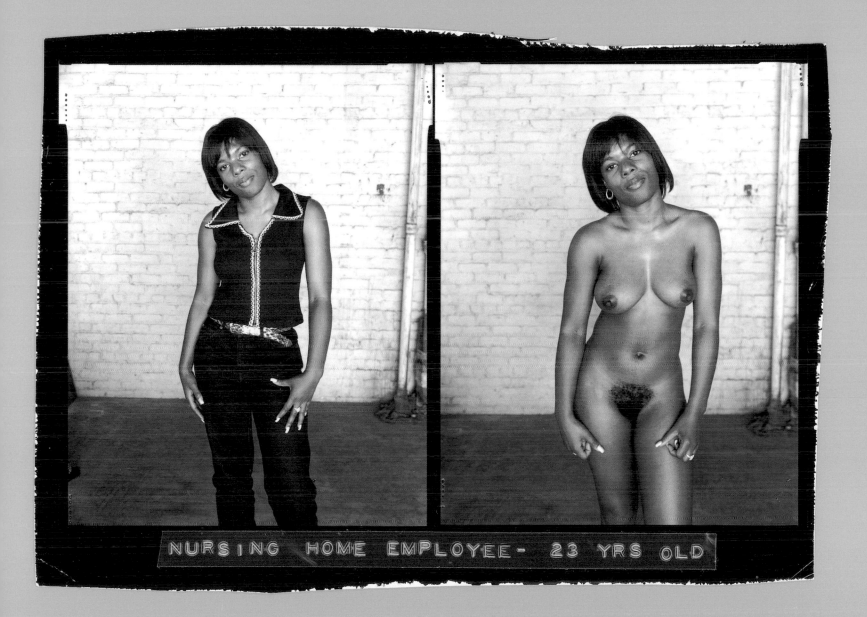

NURSING HOME EMPLOYEE - 23 YRS OLD

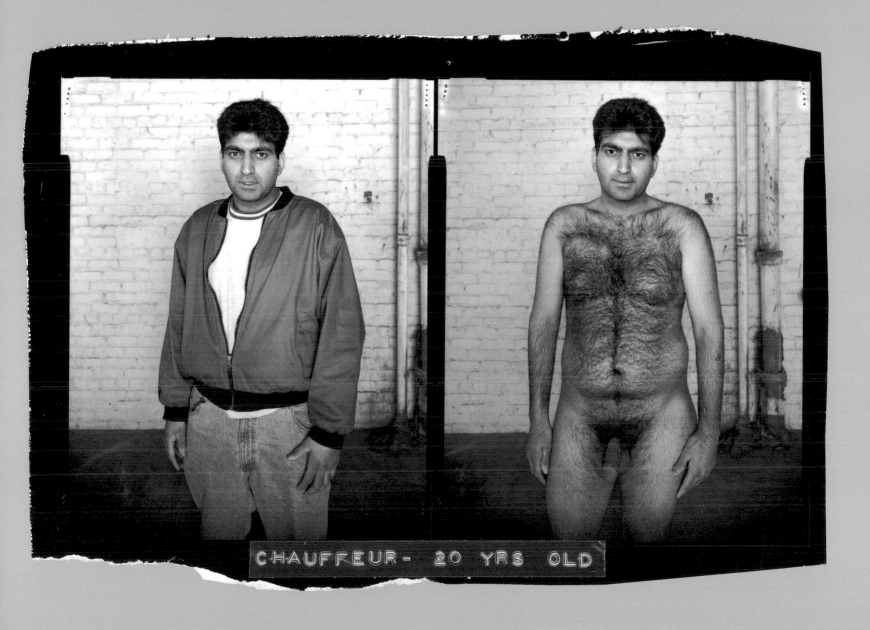

CHAUFFEUR - 20 YRS OLD

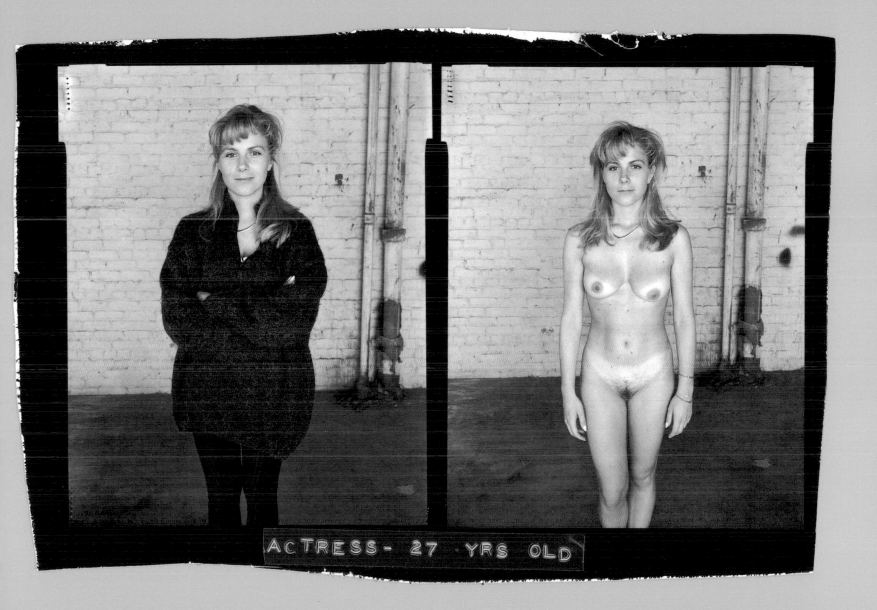

ACTRESS - 27 YRS OLD

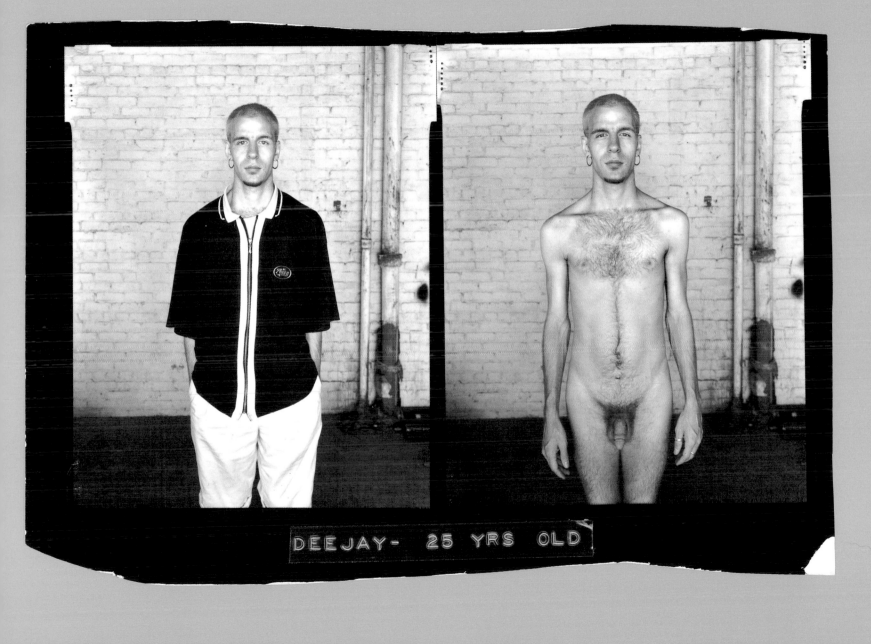

DEEJAY- 25 YRS OLD

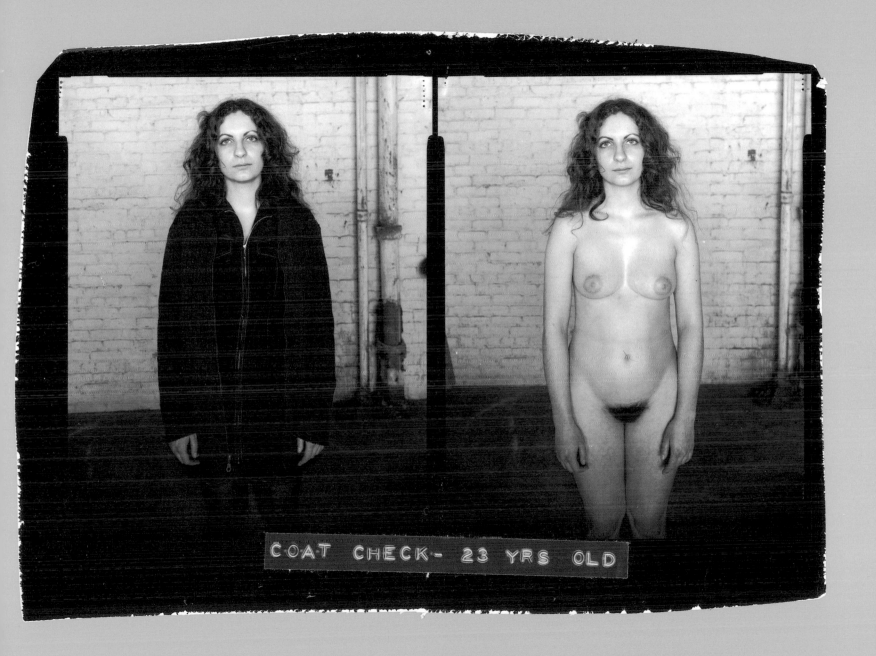

COAT CHECK- 23 YRS OLD

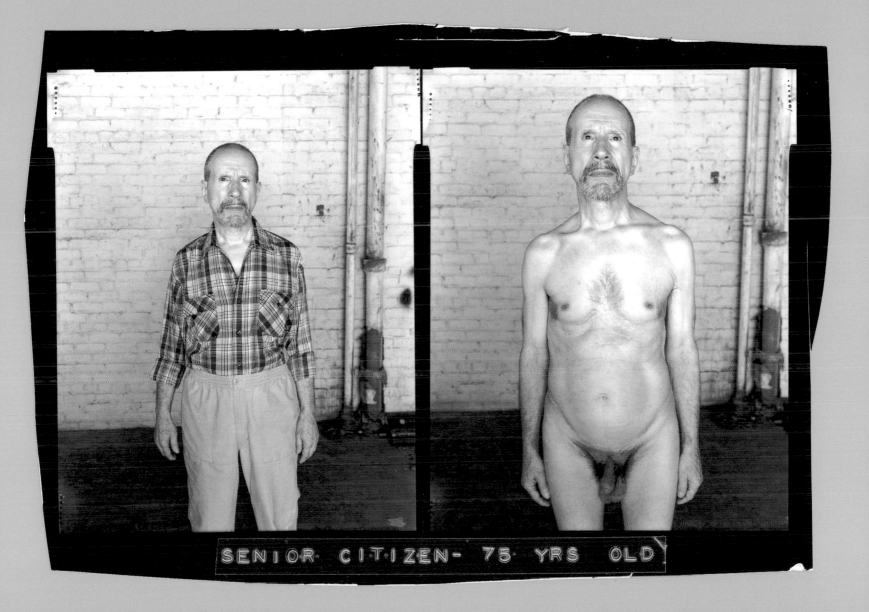

SENIOR CITIZEN- 75 YRS OLD

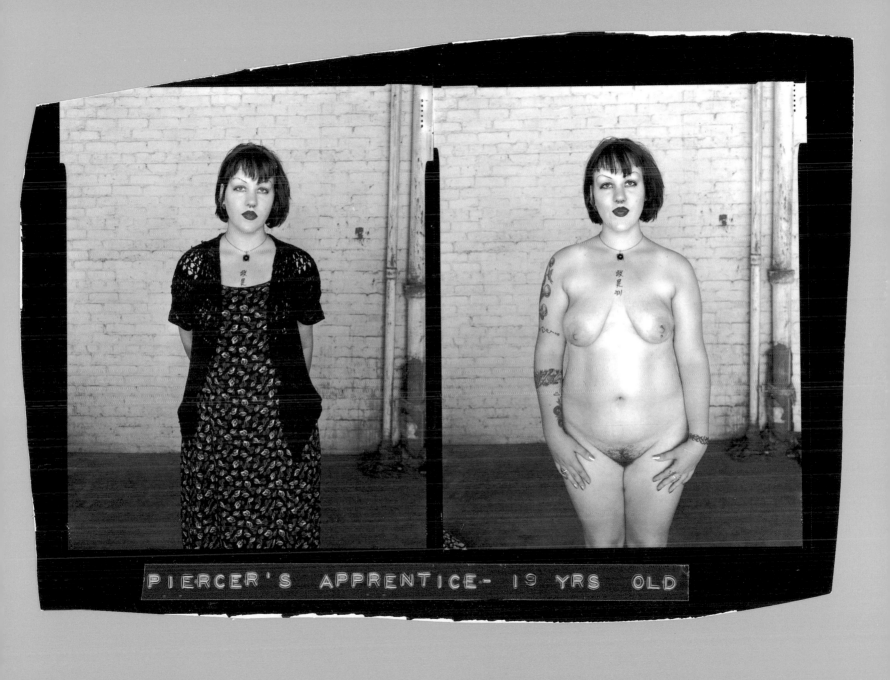

PIERCER'S APPRENTICE- 19 YRS OLD

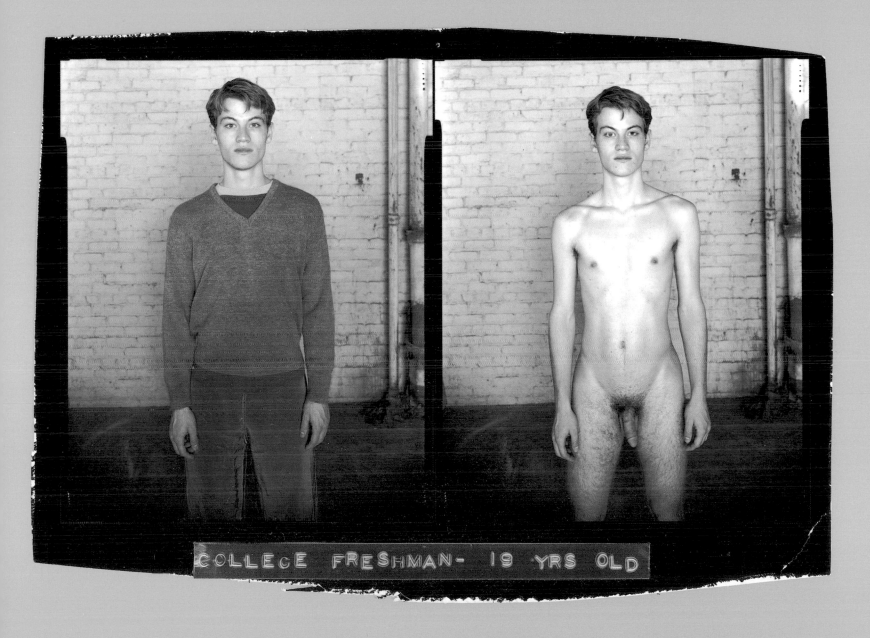

COLLEGE FRESHMAN - 19 YRS OLD

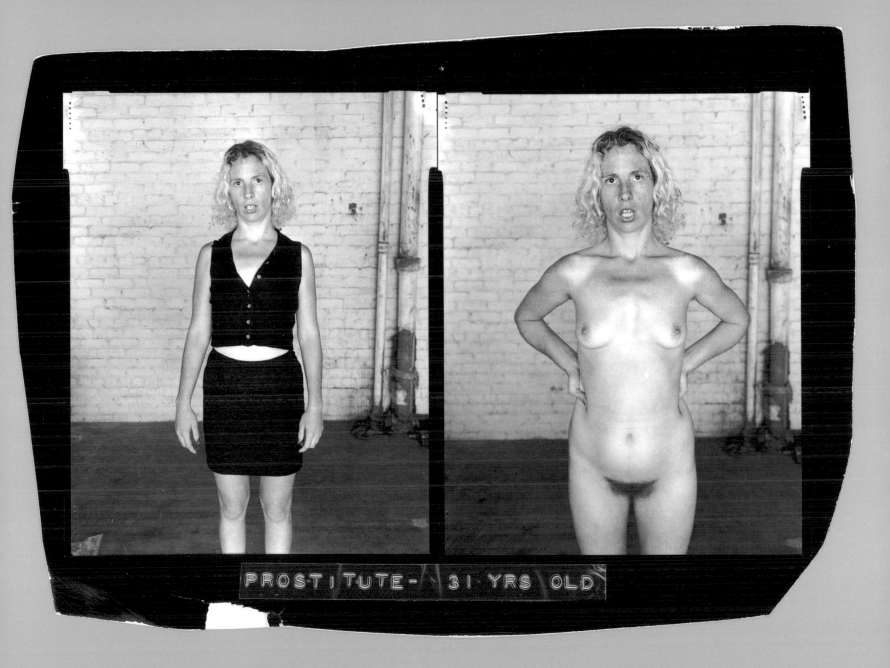

PROSTITUTE - 31 YRS OLD

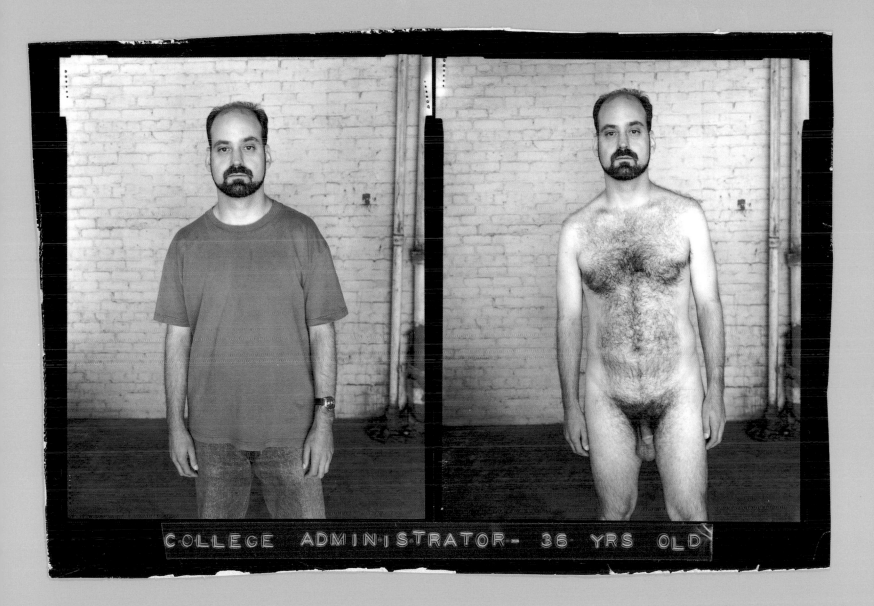

COLLEGE ADMINISTRATOR- 36 YRS OLD

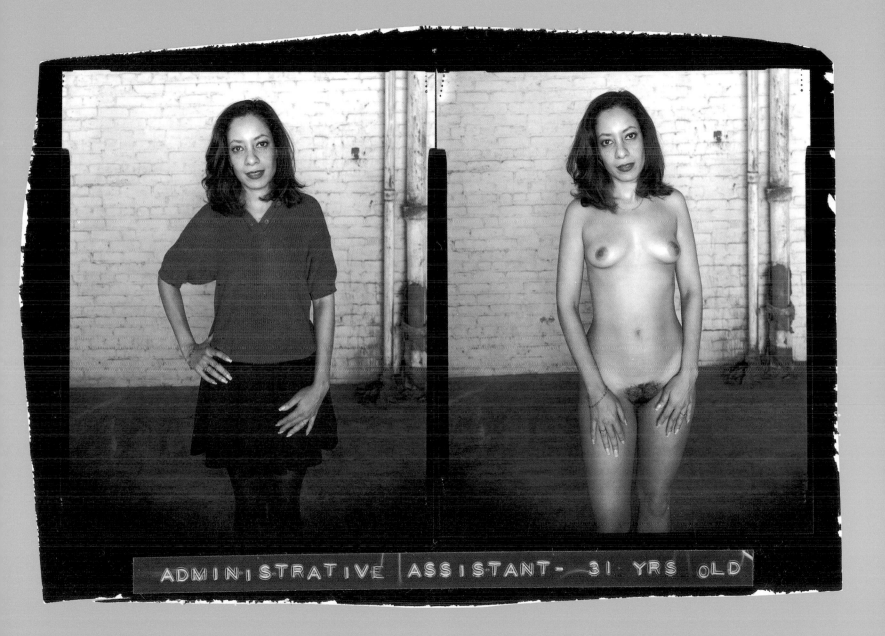

ADMINISTRATIVE | ASSISTANT - 31 YRS OLD

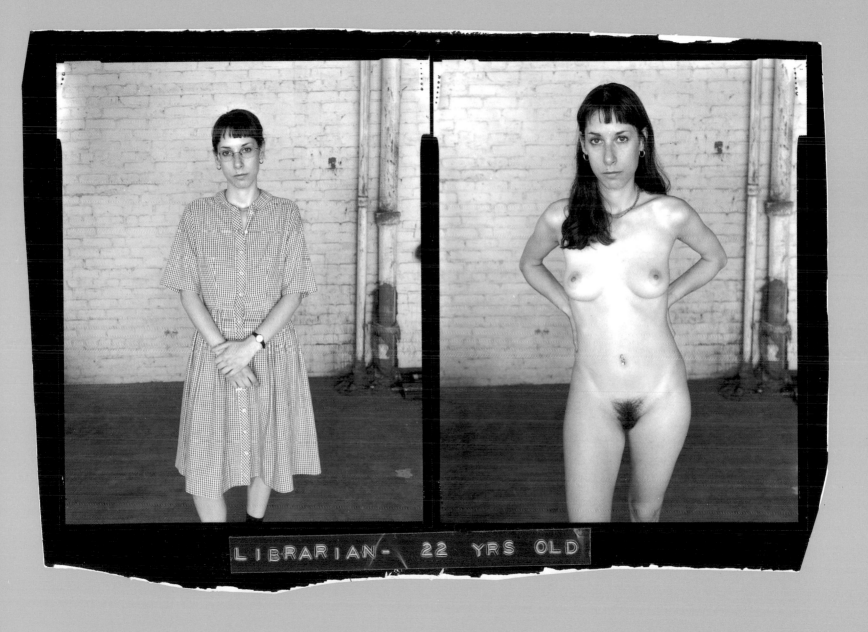

LIBRARIAN - 22 YRS OLD

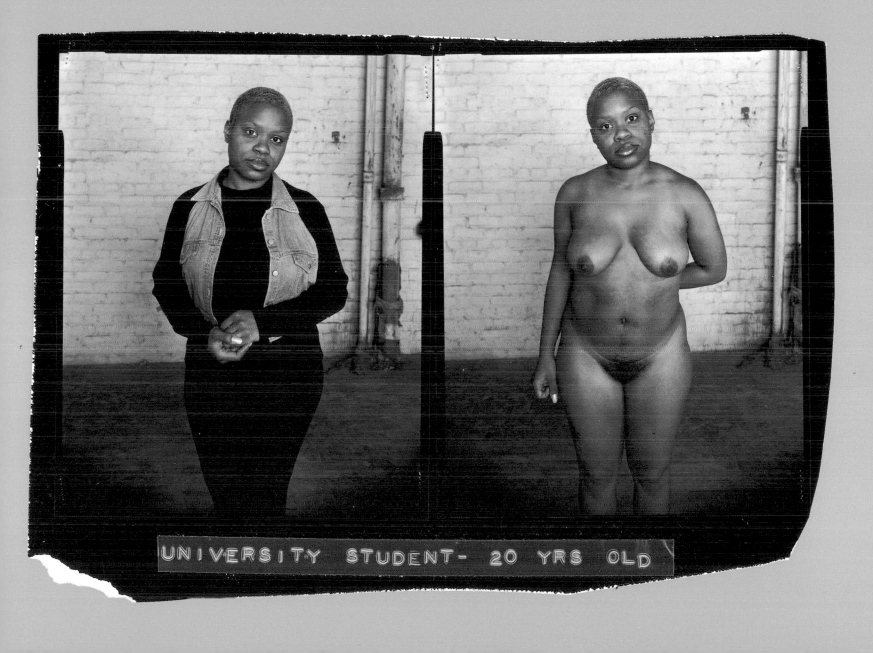

UNIVERSITY STUDENT- 20 YRS OLD

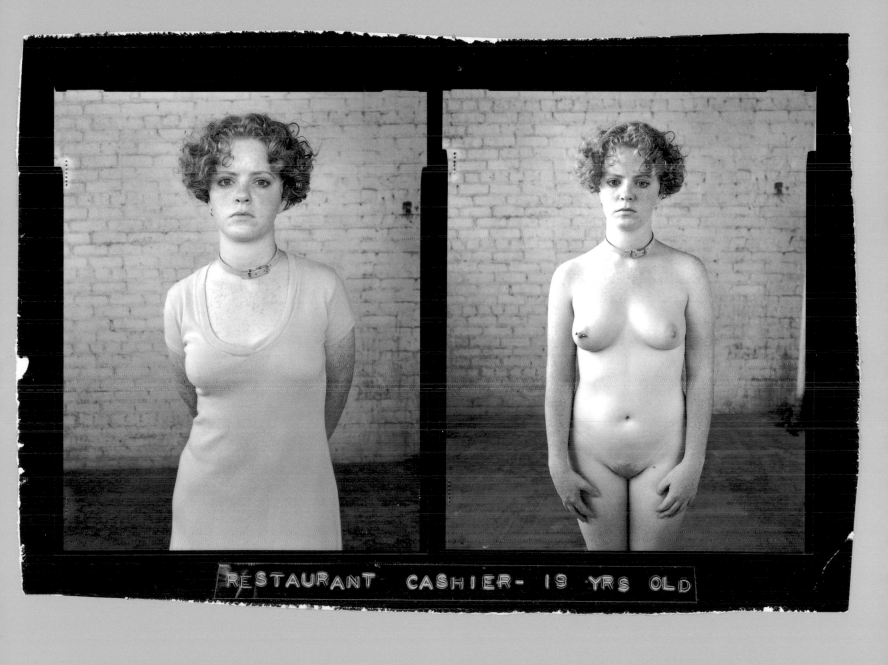

RESTAURANT CASHIER- 19 YRS OLD

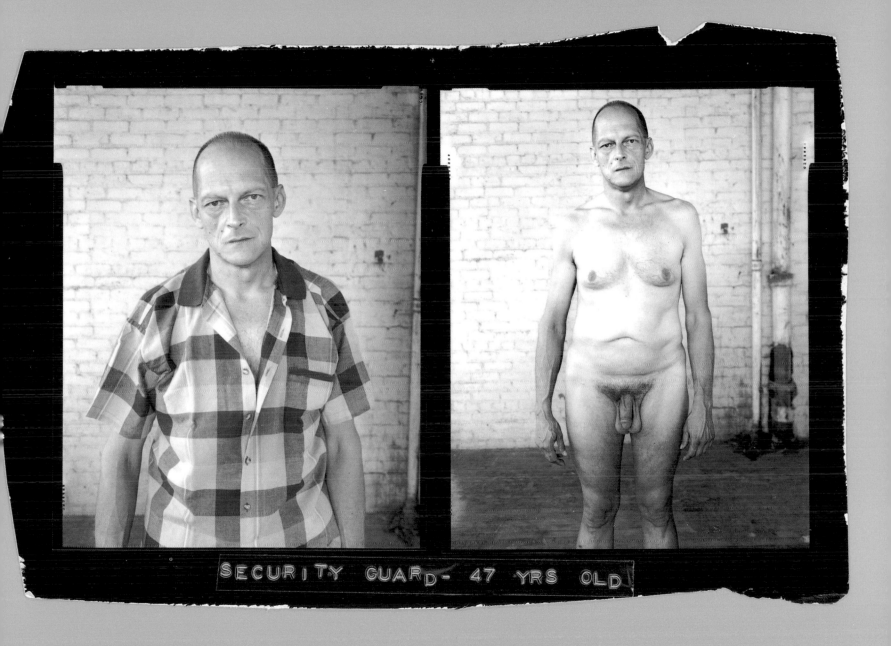

SECURITY GUARD - 47 YRS OLD

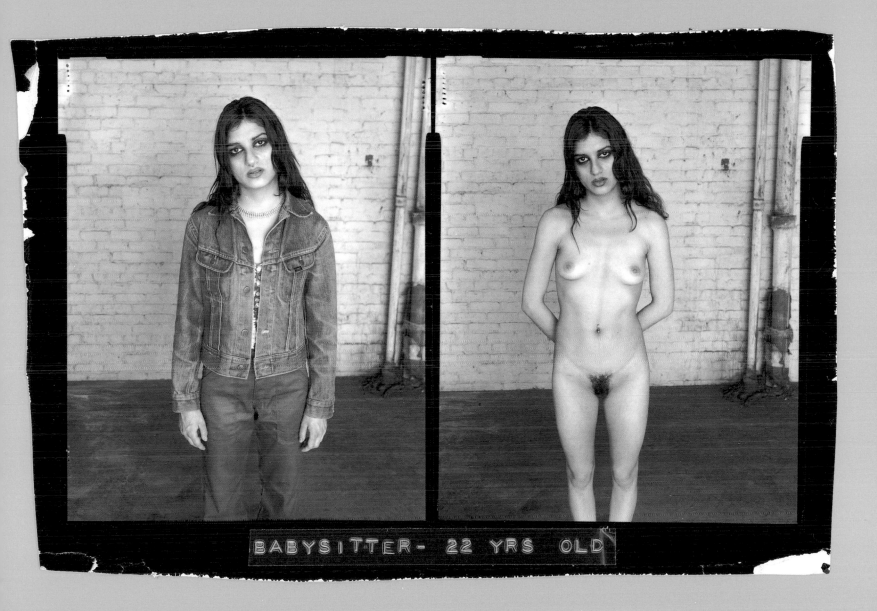

BABYSITTER - 22 YRS OLD

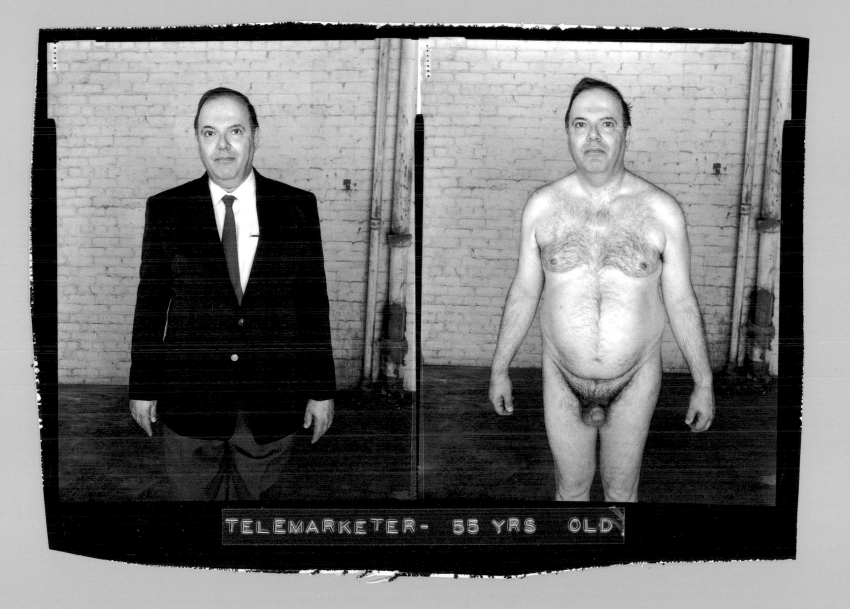

TELEMARKETER- 55 YRS OLD

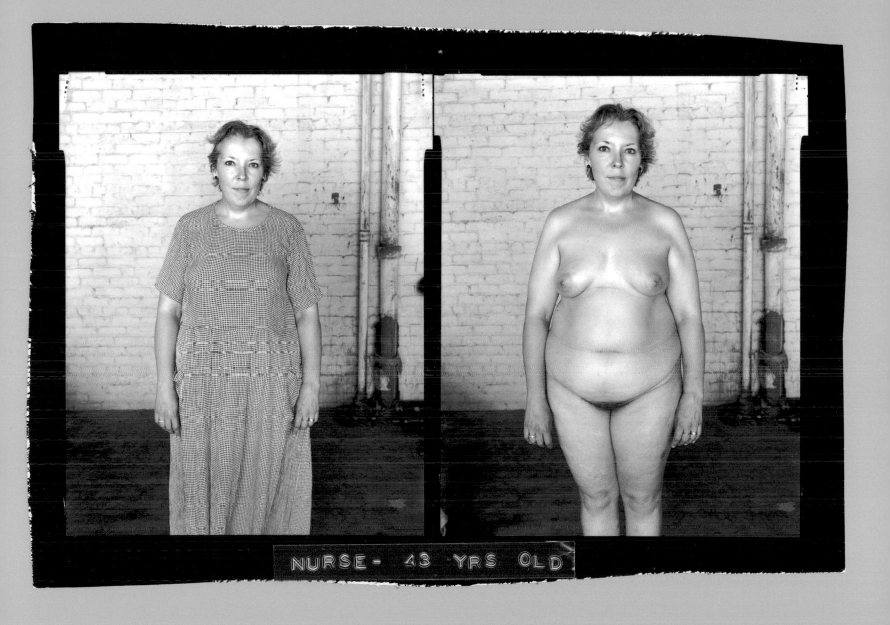

NURSE - 43 YRS OLD

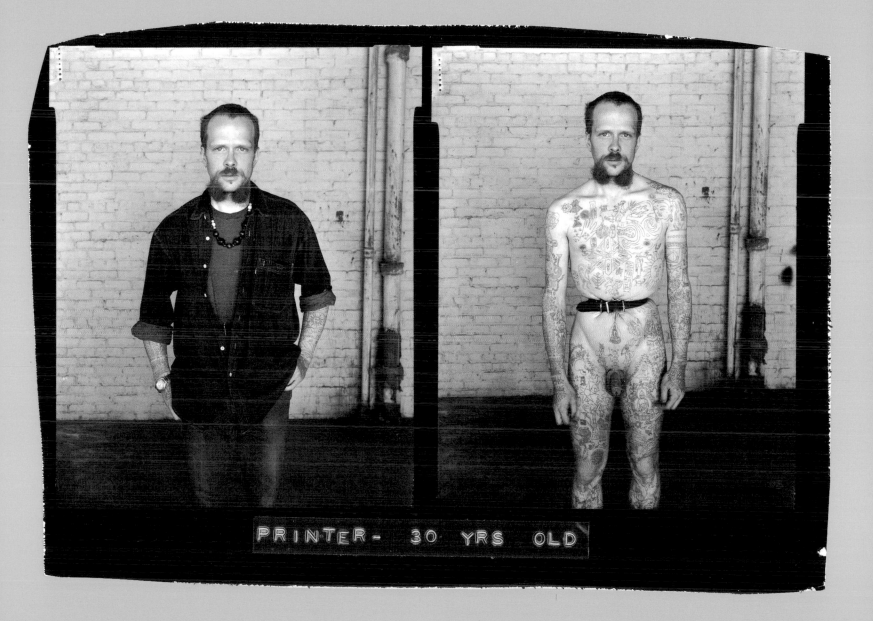

PRINTER - 30 YRS OLD

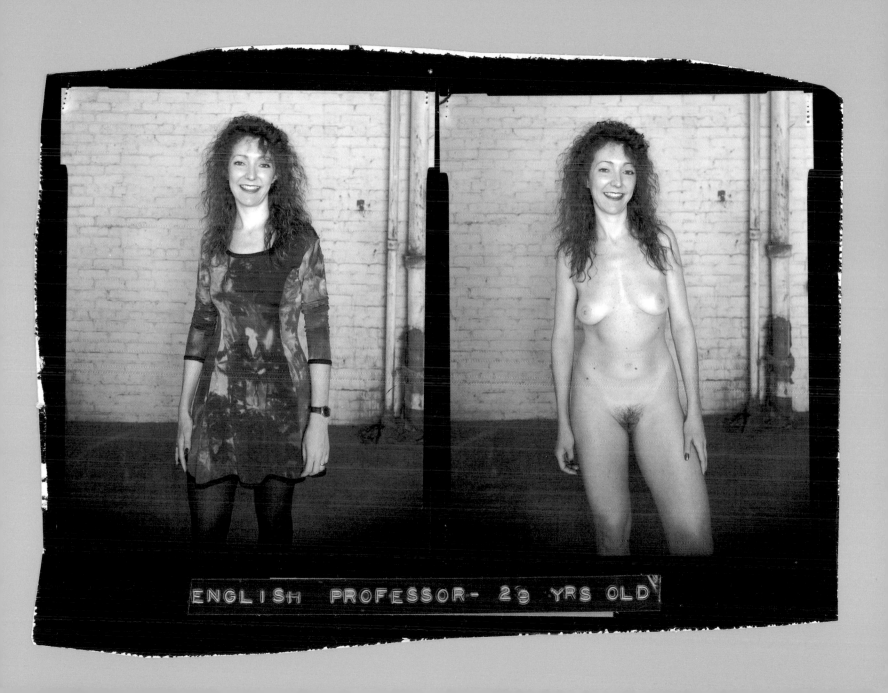

ENGLISH PROFESSOR- 29 YRS OLD

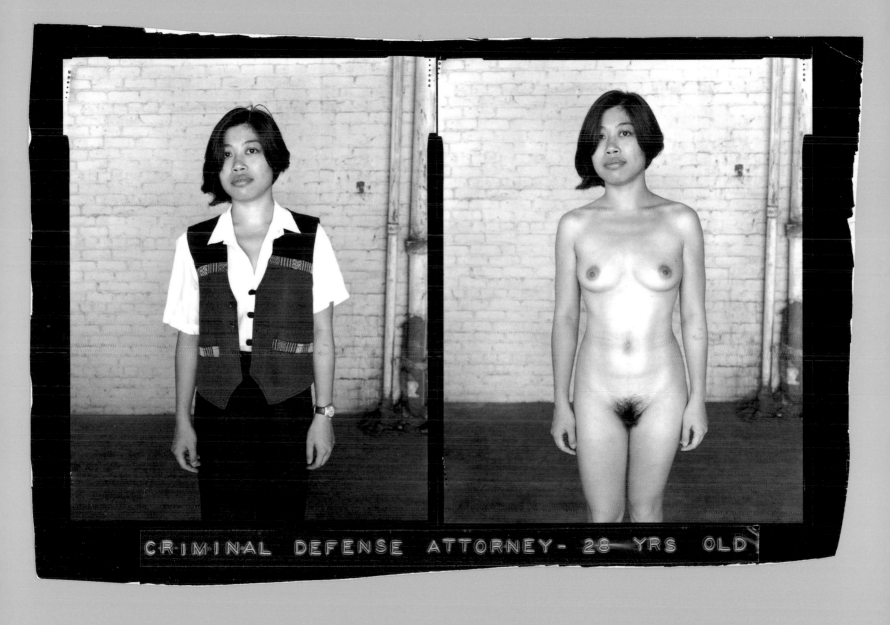

CRIMINAL DEFENSE ATTORNEY- 28 YRS OLD

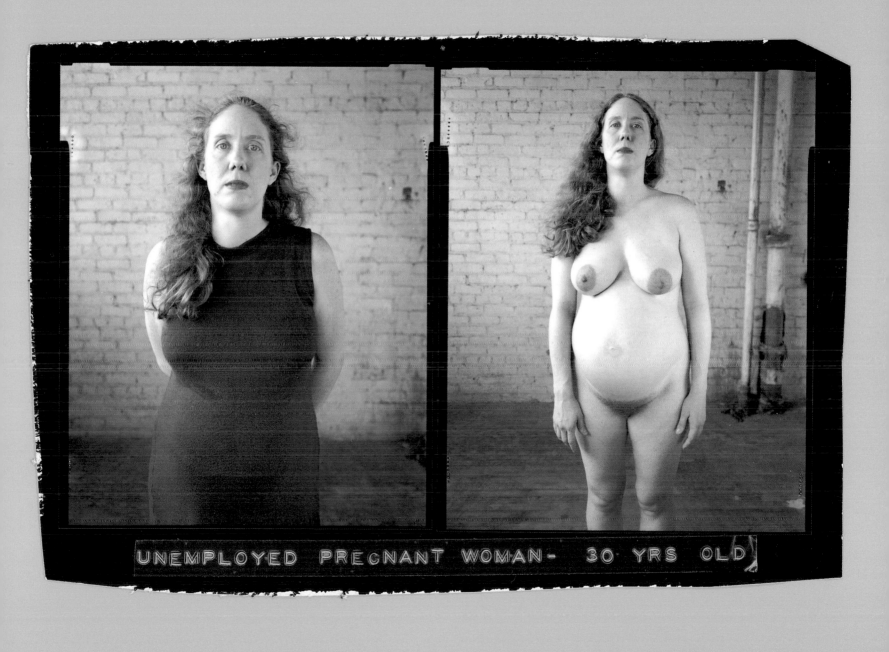

UNEMPLOYED PREGNANT WOMAN- 30 YRS OLD

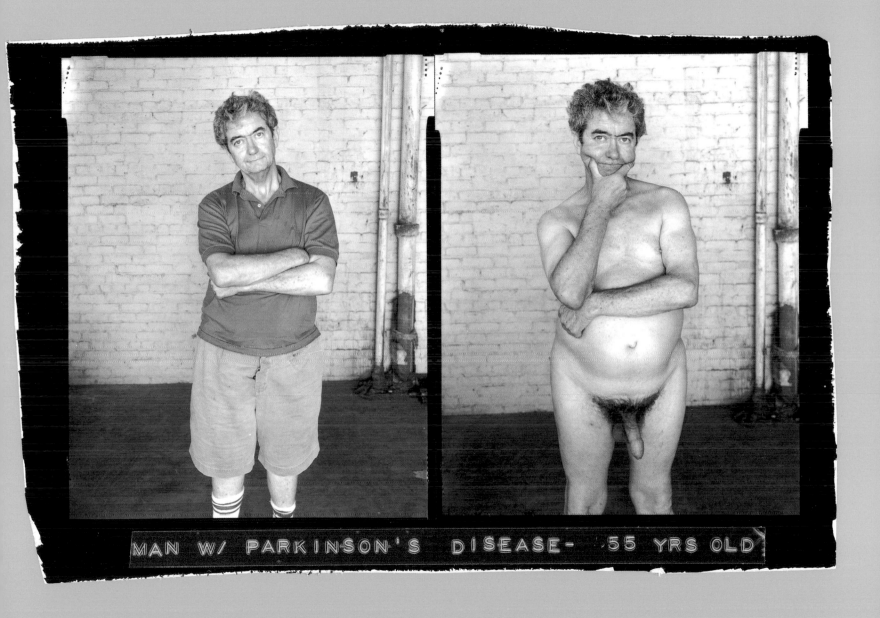

MAN W/ PARKINSON'S DISEASE- 55 YRS OLD

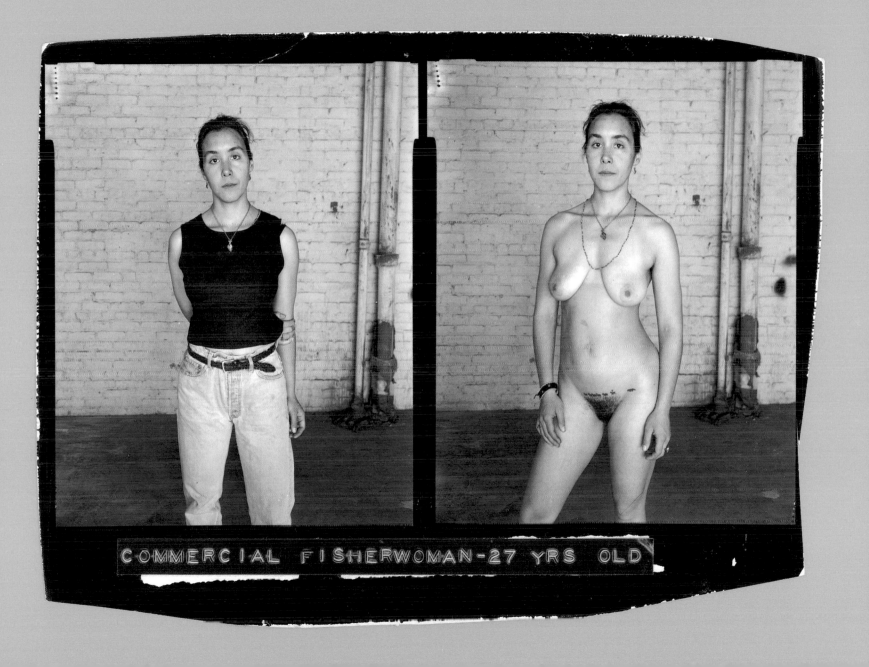

COMMERCIAL FISHERWOMAN-27 YRS OLD

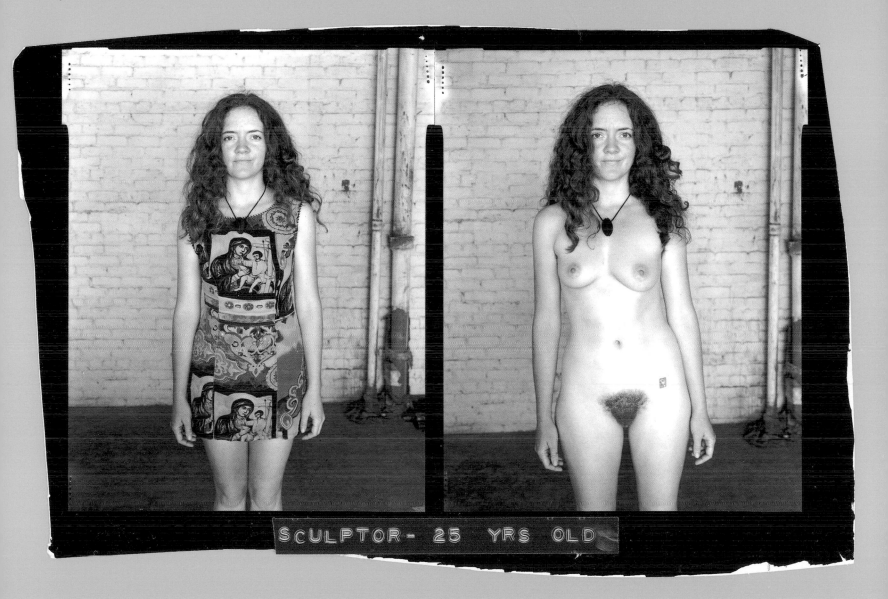

SCULPTOR- 25 YRS OLD

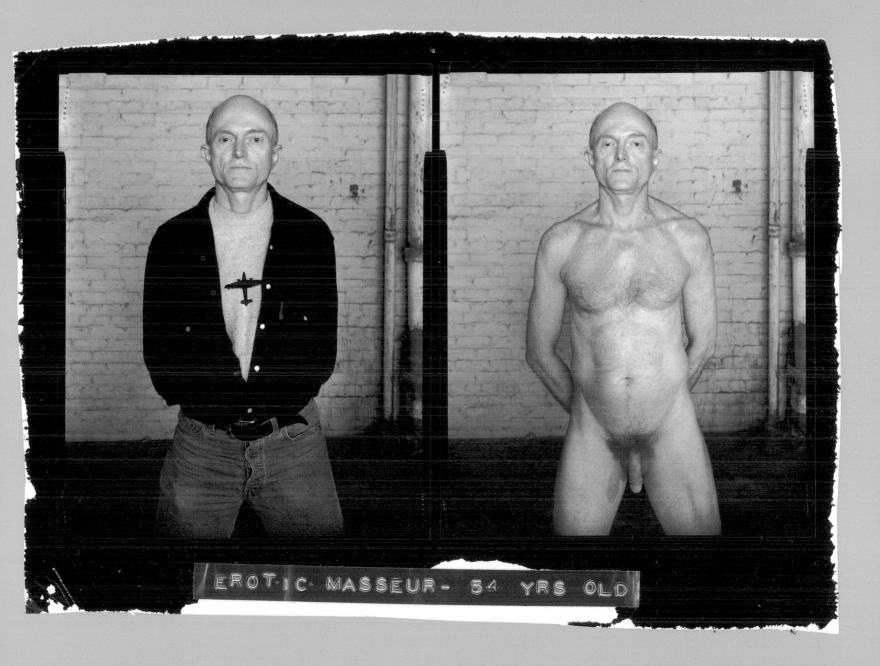

EROTIC MASSEUR - 54 YRS OLD

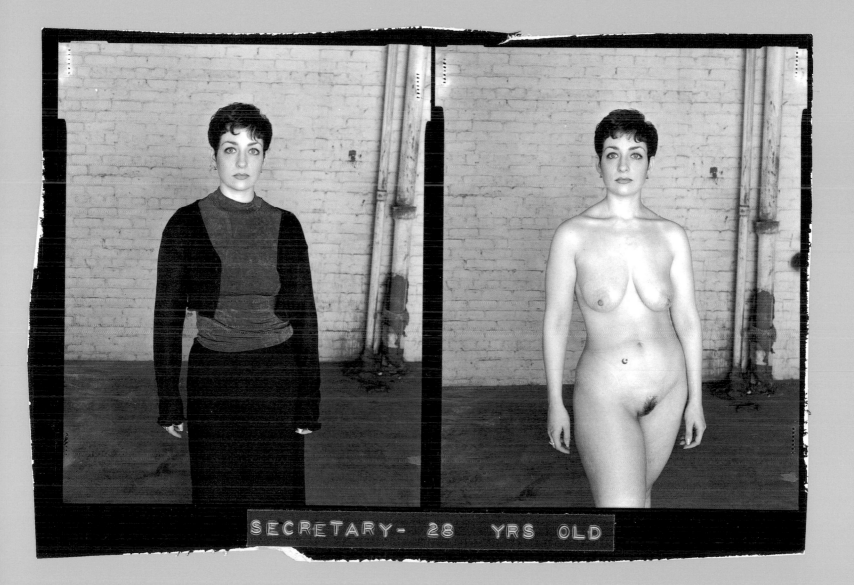

SECRETARY- 28 YRS OLD

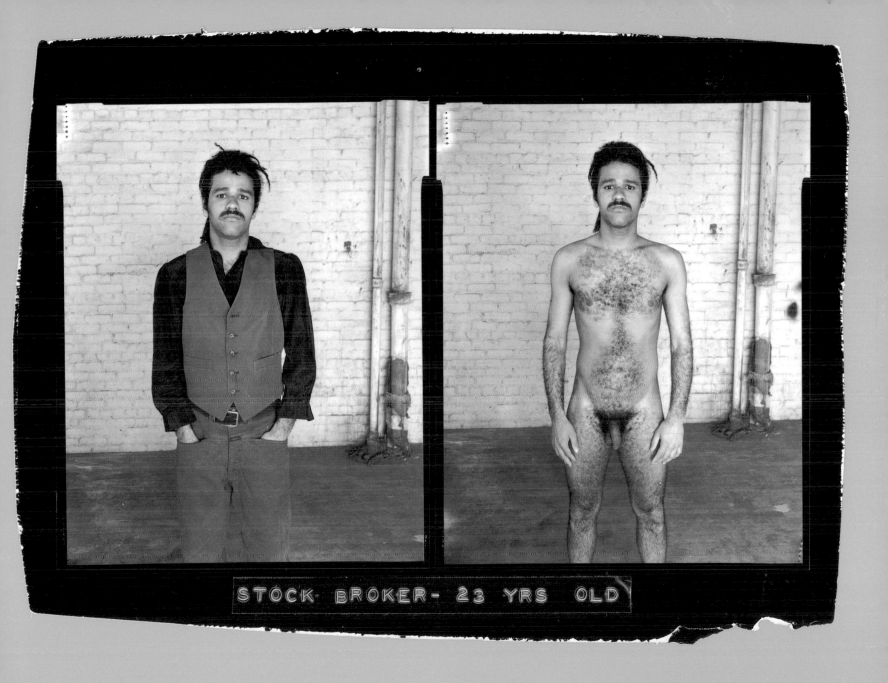

STOCK BROKER- 23 YRS OLD

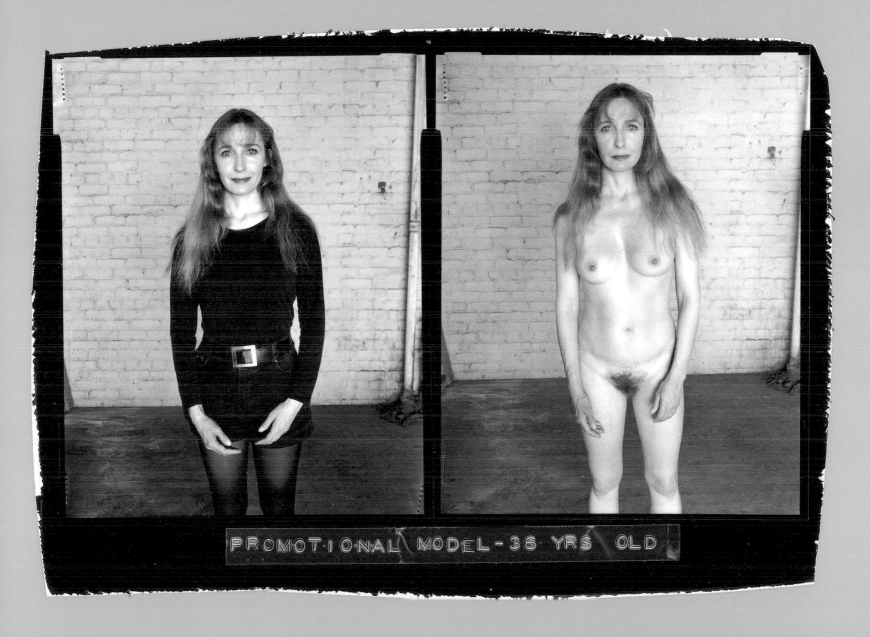

PROMOTIONAL MODEL-36 YRS OLD

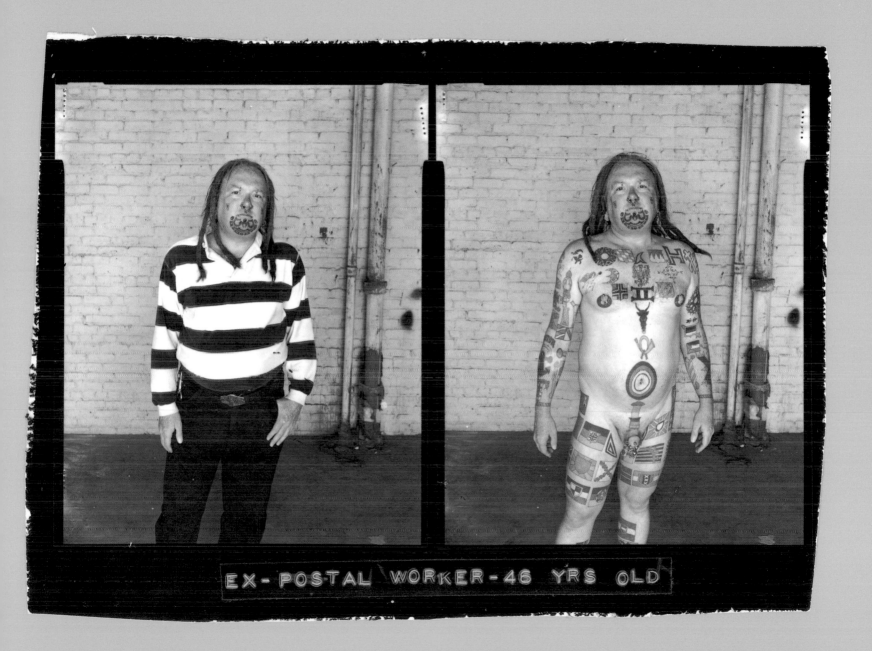

EX-POSTAL WORKER-46 YRS OLD

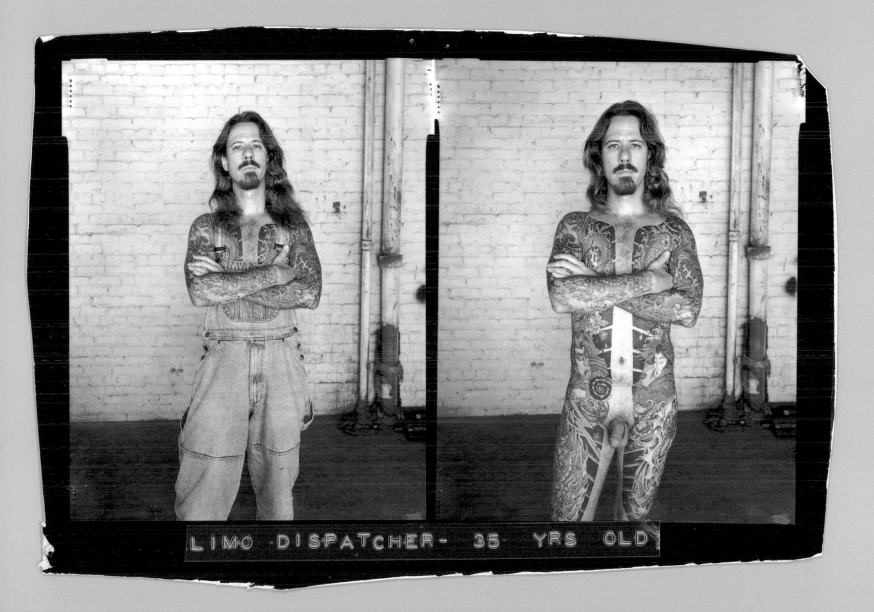
LIMO DISPATCHER- 35 YRS OLD

TECHNICAL INFORMATION

For *Naked New York*, I shot with a Linhof 4x5 inch camera and a 120 mm lens in the corner of a friend's loft. For lighting, I used an elaborate set up of strobes bounced into seamless paper to achieve a fairly natural affect. The film used was Kodak Tri-X and I printed on Ilford Multigrade fiber paper. In general, I only took four or five sheets of film for each participant.

—Greg Friedler